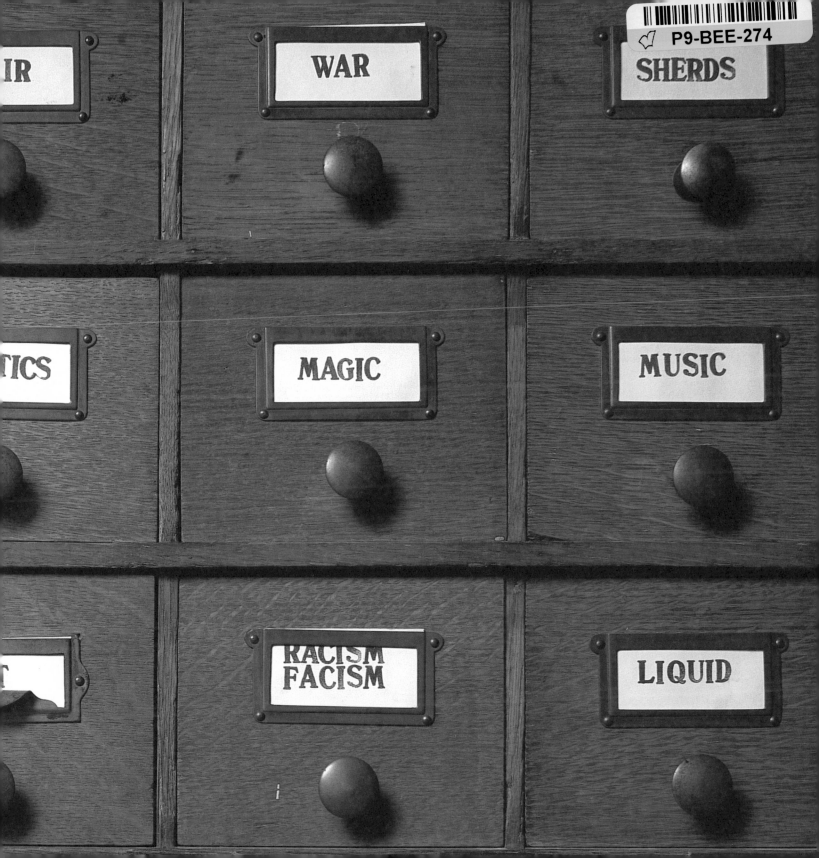

CURIOSA

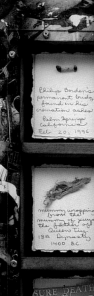
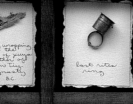

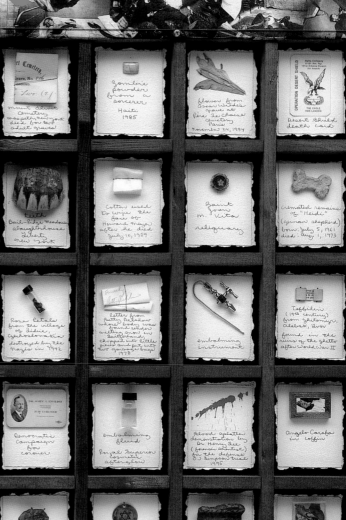
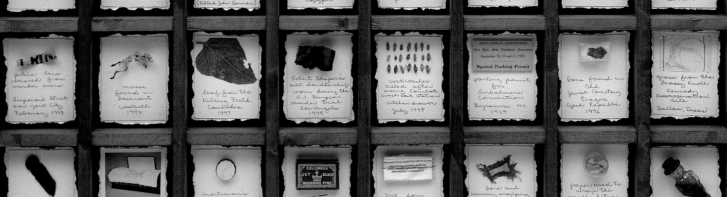

CURIOSA

Celebrity Relics, Historical Fossils, & Other Metamorphic Rubbish

Barton Lidice Beneš

INTRODUCTION BY JOHN BERENDT

HARRY N. ABRAMS INC., PUBLISHERS

DEATH MUSEUM: A collection of the macabre, of death and disease, heinous crimes, embalming, and the afterlife.

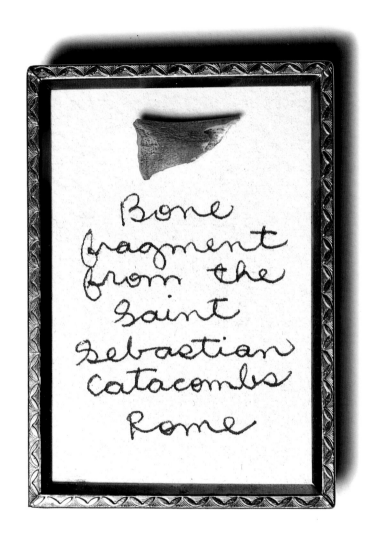

IT STARTED WITH A BONE. ¶ On my first European trip in 1963, my friend Howard and I visited the catacombs in Rome. As we followed the tour, I decided to lag just a little behind to snatch one of the bones. I took a small one, and when we got outside I showed it to Howard. He said "You put that bone back or it's going to haunt you the rest of your life." I went back in but I couldn't find the exact body from which I'd taken it. So when I got back to New York, I put it in a special case to keep the spirit happy. ¶ Over the years, I collected many more relics and visited more churches that had reliquaries. My apartment became a huge reliquarium—something I've now realized that I've modeled on the Egyptian rooms of the American Museum of Natural History in New York that I visited so much as a child. For thirty years I lived here with Howard, doing nothing to accommodate his dream of living in an empty room with four white walls and a futon. ¶ I've always been this way. When I was a kid, around the time I was visiting the museum so much, I developed an attachment to everything. I couldn't even part with orange peels. I had some kind of relation with them—the idea of throwing them away was like losing something precious. I have always been afraid of losing things. ¶ Then I lost Howard. In 1989 he died here in our apartment—I'd put a hospital bed

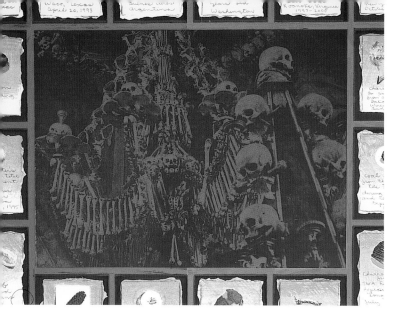

OSSUARY: A silkscreen print of the ossuary in Sedlec, Czechoslovakia.

in the studio. At the moment of his death, fluid came from his nose and I grabbed a piece of cotton to clean it off. Then, that night, there was the commotion of doctors and funeral arrangements, and I went to stay at a neighbor's apartment. The next morning when I came back to the studio, I saw that another friend had cleaned up in my absence, and removed the bed, but where the bed had been was that piece of cotton lying on the floor. ¶ I started to throw it away, and then I couldn't. It became him. The entire experience of caring for Howard was essentialized to that tiny piece of cotton, a relic of what we'd been through. I saved it for a long time and then realized that it was the foundation of an AIDS reliquary. It filled one of the boxes, like a panel in the quilt. And to it I added the other memories of fallen friends. ¶ With reliquaries, I put my passions for art and for collecting together into form. One of the first I made was about money. Society worships money, and these relics—a counterfeit bill I bought from a cab driver, a small brown paper bag with the words "please give" on it that I found on the subway, a banknote from Yugoslavia for 500 billion dinara, which at the time could only buy a carton of milk—became "sacred objects" from this religion. I went on to do reliquaries focused on celebrity culture. We look at movie stars as gods, so these celebrity

relics correspond to Christian reliquaries. ¶ On a personal level, my reliquaries are a way of documenting the lives of my friends. Because of AIDS, there is a strong element of remembrance in my work. ¶ We all have things that only we know are relics. A slip of paper with a lover's phone number, the ticket to a movie we've kept for years, or a handkerchief with a scent of perfume. Left to history, these objects fall by the wayside. We all have a drawer full of them—but when my friends died, and families often they hadn't seen for years would come to "collect their things," they invariably threw the contents of the drawers into the wastebasket. ¶ I started to get there before them—before everything was lost. And as friends—and gradually, strangers—saw what I was doing, they began to send me their relics as a way of putting them in the bank. My apartment has become a safe deposit box, a vault of memories. ¶ Without the stories, these objects mean nothing, but when they are mounted they become special. And when the provenance is attached they become interesting, and when they are combined with many more similar objects in a collection, they become art. ¶ —Alone they're simply memories—placed together, in the right order, the objects create a visually interesting museum that reads like a book or a musical composition. ¶ I always look forward to going

down for my mail. Several times a week I receive some treasure. I never know what surprise will be waiting. I have a large cabinet with many drawers, each labeled—disasters, fascism, sex, crime, hair, and magic, for instance—and I store all the relics that fit into these labels here. ¶ I also mount them in a large case of cubbyholes hanging over my worktable. I put them in randomly after I mount them and as I sit there I see subjects for museums start to define themselves. Neighborhoods form in the cubbies, and I'll start to notice several things that have to do with each other—disasters, for example,—and that is how the museums are born. ¶ When I see a good subject, I put the word out. I let everyone know what my latest project is, and wait for relics to arrive. It is great to know lots of people who work in the news, such as reporters and producers. These people always keep my relics up to date with current events. I am lucky to know so many different types of people who can provide great relics. Movie stars, politicians, archaeologists, artists, musicians, lawyers, etc—people from all over the world. Waiters are some of my best sources.¶ Because everyone loves to participate in my reliquaries, they are collaborative pieces. People are excited to help me find things, and even more so when they come to a show and can say, "I gave him that!" Every time an audience sees these

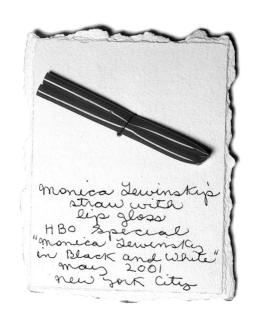

monica Lewinsky's
straw with
lip gloss
HBO Special
"Monica Lewinsky
in Black and White"
may 2001
new york City

works, they too want to become involved in their creation. I love this, as it makes me feel connected—that I am not just out there all by myself. ❡ I also trade for relics, but they have to be very good for me to do that. I have bought some relics, but like I said before, they must be FABULOUS. I met an artist who had Monica Lewinsky's used straw, so we bartered. I gave him some of Son of Sam's hair. ❡ Another artist had a communion wafer from the funeral of John F. Kennedy Jr.; he promptly removed it from his mouth at communion. I gave him a jar of teeth that I had collected. Then there was a student in Oslo who wanted to sell me a relic for lots of money, and I didn't buy it because it was way too expensive. It was a piece of glass from the broken skylight at the Oslo museum after the theft of an Edvard Munch painting. I regret being so cheap now. ❡ Whenever I have an exhibition, the question arises, "Are the relics real?" I use only real relics and I keep every letter that comes with the pieces to authenticate them. Lots of people say "Yeah, how about a piece of the original cross?" I love it when they ask that, because at my last show in Portugal I bought a very tiny splinter of wood, which is supposedly from the cross on which Christ was crucified. So I tell them that I already have a piece! ❡

— BLB

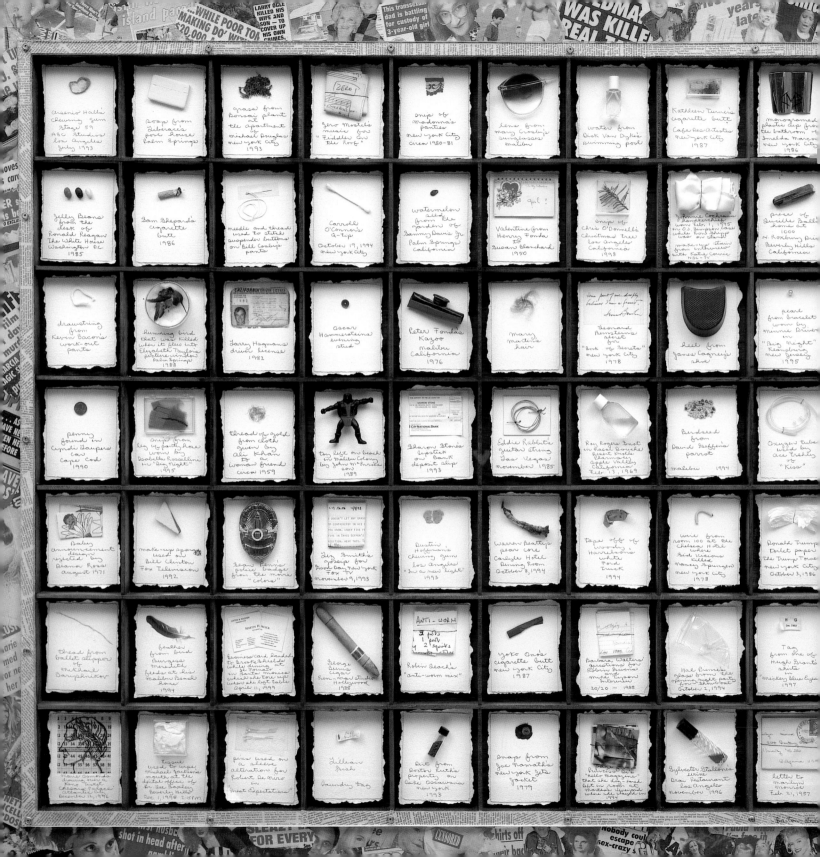

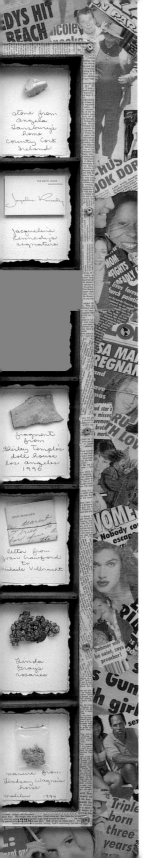

INTRODUCTION BY JOHN BERENDT

TOWARD THE END OF MARCH, 1999, BARTON BENEŠ got a letter in the mail from the Harvard Law School. "Dear Mr. Beneš," it read, "I am enclosing the glove that I used to conduct the experiments on regarding the possible planting of evidence by Mark Fuhrman in the O.J. Simpson case. When the glove was dampened and left outside in conditions simulating those in Los Angeles on the night of the murder, it dried quickly. But when the same dampened glove was sealed in a baggie, it remained moist. Fuhrman claimed the glove he found was moist when he found it hours after the killing. Sincerely, Alan Dershowitz." ¶ Beneš slipped the letter into a wooden file cabinet in the neat but cluttered, high-ceilinged space in Manhattan's West Village that serves as his office, his archive, his museum, his atelier, and his home. And there it has remained with over a thousand other such documents—letters, photographs, affidavits— certifying the provenance of the odd things he uses to make his works of art. As for the glove itself, Beneš would later snip it into hundreds of tiny pieces which he would then mount on paper or assemble in some meaningful way as a

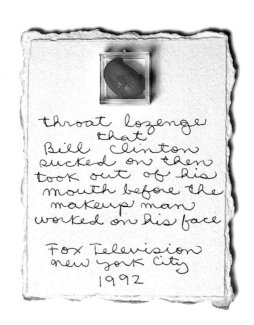

throat lozenge
that
Bill Clinton
sucked on then
took out of his
mouth before the
makeup man
worked on his face

Fox Television
New York City
1992

work of art. ¶ Barton Beneš makes art out of ordinary objects—a fingernail clipping, a few squares of toilet paper, a five-inch fragment of charred insulation, a piece of a linen napkin smeared with chocolate soufflé, a shard of broken glass, a half-dissolved throat lozenge that's been sucked on and spat out. ¶ These things are trash, really, the debris of everyday life. The difference is that the sliver of fingernail happens to have been clipped from Frank Sinatra's finger. The toilet paper was taken from a bathroom in Buckingham Palace. The charred piece of insulation had washed ashore from the wreckage of TWA Flight 800. It was Nancy Reagan who wiped a dribble of chocolate soufflé from her lips onto the linen napkin, the shard of glass came from Princess Diana's fatal car crash, and Bill Clinton spat out the throat lozenge. ¶ Mind you, these objects are still trash, despite their notable origins. But they are trash touched by fame, and the fame transforms them into relics, and Barton Beneš transforms the relics into art. In his handsomely constructed reliquaries, Beneš assembles dozens of pieces of inconsequential minutiae. By themselves and together, they are poignant, funny, morbid, and often enough more than slightly absurd. Beneš mocks our obsession with celebrity, our desire to be in the presence of "history," to connect with something famous. An impish humor presides over the

entire enterprise, but nevertheless it is a serious undertaking. These relics perform the function of a remarkable time capsule. They are a chronicle of our times and the authenticity of each one is documented and kept somewhere in Barton Beneš's wooden file cabinet. The manicurist who snipped Sinatra's fingernail wrote a brief note; Beneš has a photograph showing Nancy Reagan wiping her mouth with the napkin; an editor from Fox News confessed in a letter to Beneš that she swiped the half-sucked lozenge from an ashtray in the green room after Clinton had been there for an interview. ¶ The lozenge in particular reminds me of the evening I first met Barton Beneš. It was at a dinner party in New York a couple of years ago. Barton arrived with a framed "reliquary" as a present for the host. It consisted of sixteen tiny fragments, each no bigger than a quarter of an inch by half an inch, mounted on paper and labeled with a hand-written caption: "fragment from Adolf Hitler's house in Berchtesgaden," "snip from Andy Warhol's film *Empire*," "Sharon Stone's powder puff, New York City 1996," and so on. When the general commotion over the reliquary had died down, I went over to Barton. ¶ "I have something I think you might like," I said. ¶ Barton's eyes lit up. "Really!? Tell me what!" ¶ "Back in the early seventies," I said, "I worked as a writer for the "David Frost Show." My job

was to interview the guests beforehand and write questions that Frost could use on the air. One day I interviewed Roy Rogers and Dale Evans. I can't remember anything about what they said, but something happened after they left the studio that I remember very well. One of the makeup ladies came up to me and said, 'Roy Rogers left this in his dressing room. I'll let you decide whether to throw it out or send it to him'" ¶ It was a medicine bottle, the old type made of clear glass with a black plastic screw top, the kind you used to get cough syrup in. This one had a watery liquid in it, slightly cloudy with tiny feathery white fragments floating in it. The Desert Knolls Pharmacy label had the following words typed on it: "Roy Rogers. Nasal Douche." ¶ Roy Rogers was a well-known preservationist, as everyone knows. When his horse Trigger died, he had him stuffed so his fans could view him throughout eternity. Why shouldn't Roy's own mucus be accorded the same consideration? ¶ I kept the bottle, not knowing what, if anything, I would do with it—that is, until thirty years later when I met Barton Beneš. Today Roy Rogers's mucus has taken its place in the Barton Beneš oeuvre in a suite of relics entitled "Excreta," which also includes a vial of Sylvester Stallone's unflushed urine, a gob of Miss America's saliva, and a dollop of fossilized, 25-million-year-old feces. ¶

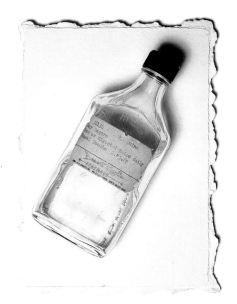

Roy Rogers's nasal douche.

Most of Beneš's relics are simply mounted on heavy Arches paper and installed in a single wooden frame or a honeycomb of frames in which the power of the piece is doubled by the incongruous, indiscriminate mix of items. With some of the relics, the best in my opinion, he goes one step further and creates a shape that symbolizes the relic itself in some way. He calls this series "Transubstantiation." For example, he uses oil from the *Exxon Valdez* oil spill as the ink with which he makes a rubber-stamp print of a heron. He stuffs snippets of artist Mark Rothko's tie into pill capsules, recalling Rothko's suicide. He assembles splinters of wood from O.J. Simpson's house at 360 Rockingham into the shape of a dagger. He uses water from Dick Van Dyke's swimming pool to paint a watercolor picture of the pool itself. He models Monica Lewinsky's napkin into the shape of lips. He molds a piece of wallpaper from the set of *Psycho* into the shape of a bathtub plug. Perhaps his most disturbing relic is a small model of an airplane made out of the charred pieces of insulation from the crash of TWA 800, mounted on a piece of paper so that it appears to be on a sharp, downward trajectory, trailing smoke. ¶ Beneš comes by his interest in relics through his family roots in Sedlec, Czech Republic, a village 50 miles from Prague. The town was founded in the twelfth century, and legend has it

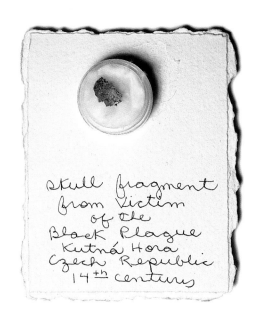

skull fragment
from victim
of the
Black Plague
Kutná Hora
Czech Republic
14th century

that shortly afterward, a handful of dirt from Christ's grave was brought to Sedlec and sprinkled over the graveyard of the Church of All Saints. This made the church an enormously popular shrine for pilgrimages in Central Europe, and the graveyard itself became a much sought-after burial place. Then in the fourteenth century, when the Bubonic Plague killed a third of the people in Europe, the graveyard was suddenly filled to overflowing. In order to conserve space, more than 40,000 bodies were dug up, and their bones were gathered together as an ossuary. A local woodcarver was engaged to arrange them in fanciful designs resembling architectural details such as pinnacles, arches, brackets, urns, and even a coat of arms. His masterpiece is a chandelier that is said to contain every bone in the human body. Today, hundreds of years later, the ossuary is one of the Czech Republic's major tourist attractions. And as a Sedlec descendant, Beneš has carried on the reliquary tradition in his own way. His collection does, in fact, have a few bones in it—the hip bone of museum director Laurel Reuter, an anonymous human toe found on the Williamsburg Bridge between Manhattan and Brooklyn, a piece of a mummy's foot from the Ptolemaic period, and even a skull fragment from a victim of the Black Plague whose bones were part of the ossuary at the Church of All Saints in Sedlec. ¶ Beneš is

a third-generation Czech-American who grew up in New York City and studied painting and art history at Pratt Institute. He has a highly developed sense of his Czech origins, not only because of continued family ties but because his father gave him the middle name of Lidice, the name of a Czech village that was the scene of a Nazi atrocity in 1942, the year Barton was born. That year, in response to the killing of a German officer, the Nazis murdered every adult male in the village, then sent the women and children to concentration camps and burned the town to the ground. Beneš always includes his middle name whenever he signs his work. ¶ After finishing school, he started out as a painter, but his focus changed completely when he went to the Ivory Coast in 1971 to paint a mural and became fascinated by West African masks, fetishes, and other artifacts. "That was the last painting I ever did," he says of the mural. From that moment on, he has devoted himself to commenting on American culture through its relics and artifacts. ¶ His work as a reliquarian took on an aspect of biting satire when, as he recounts it, in 1991 he cut himself chopping parsley and got blood all over the kitchen counter. It suddenly dawned on him that his blood, which he knew was HIV-positive, was a relic of stunning timeliness. HIV blood is poison. It kills. And for that reason it is feared,

condemned and reviled by society. Beneš focused on this fear, using his own HIV-infected blood to create a series of AIDS weapons. He filled a water pistol with it and mounted it on paper under wired safety glass with a spray of blood on the paper so it looked as if the water pistol had been fired. He did the same with a perfume atomizer, and he also made an AIDS Molotov cocktail and a poison AIDS dart. The exhibition, "Lethal Weapons," toured the world and created a sensation at every stop. The British tabloids went predictably berserk, trumpeting "AIDS Horror Show." The show was quarantined in Sweden where the authorities took the blood to a hospital and heated it to 160 degrees for two hours to kill the virus. "I had become a terrorist," he says. More precisely, he'd become a virtual terrorist. ¶ While the AIDS hysteria has settled down considerably, the issue has not gone away, and Beneš has kept at it in a more subdued, but no less cutting, manner. He showed his contempt for AIDS ribbons by making one out

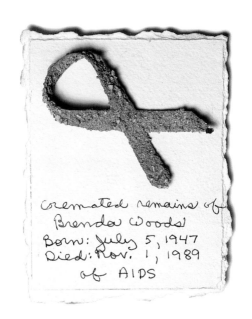

cremated remains of
Brenda Woods
Born: July 5, 1947
Died: Nov. 1, 1989
of AIDS

of the ashes of a dead friend. He mocked the brightly colored toxic medicines he takes by pasting them to the surface of a painter's pallet. A dish on his desk contains the broken pieces of a ceramic bowl, a photograph of someone lost to AIDS pasted to each one. And as a bittersweet tribute to two lovers who had both died, he mixed their ashes in a three-foot-high hourglass which he up-ends every so often. ¶ Barton's most pressing concern these days, as always, is finding new relics. He searches the web for hours, he writes letters, he badgers friends, and he keeps a lookout for the chance discovery. ¶ Recently he attended a dinner at the American Museum of the Moving Image in Queens. "They knew all about my reliquaries, and I felt as if I was the center of attention." ¶ "That's quite an honor," I said. ¶ "Not really," he said with a laugh. "I guess I asked too many questions about the bride's wig from *The Bride of Frankenstein*. They didn't let me out of their sight until I was out the door." ¶

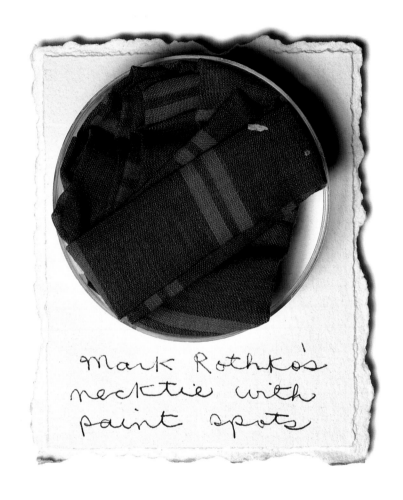

Mark Rothko's
necktie with
paint spots

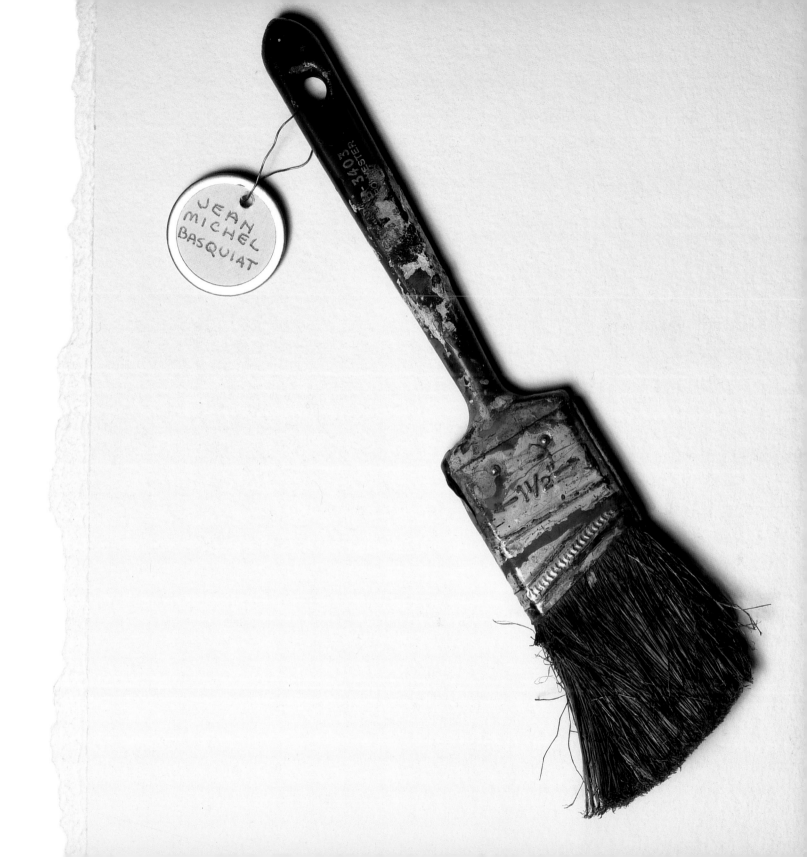

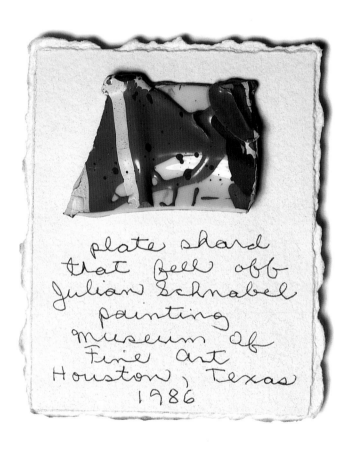

plate shard
that fell off
Julian Schnabel
painting
Museum of
Fine Art
Houston, Texas
1986

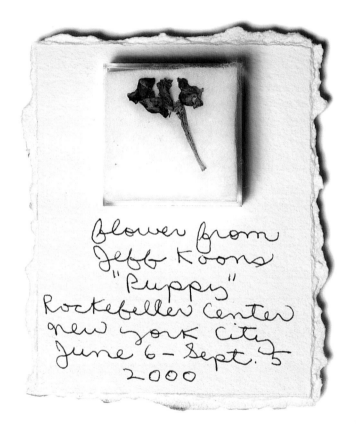

flower from
Jeff Koons
"Puppy"
Rockefeller Center
New York City
June 6 - Sept. 5
2000

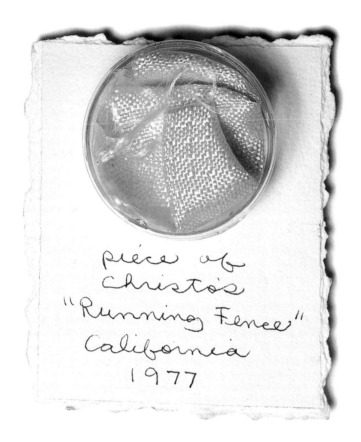

piece of
Christo's
"Running Fence"
California
1977

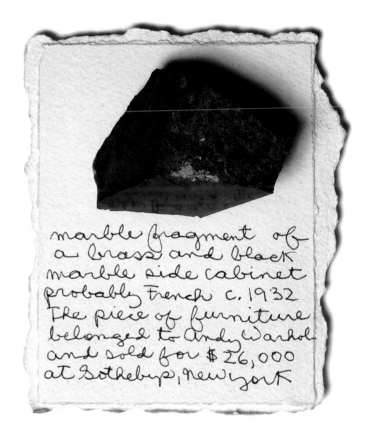

marble fragment of
a brass and black
marble side cabinet
probably French c. 1932
The piece of furniture
belonged to Andy Warhol
and sold for $26,000
at Sothebys, New York

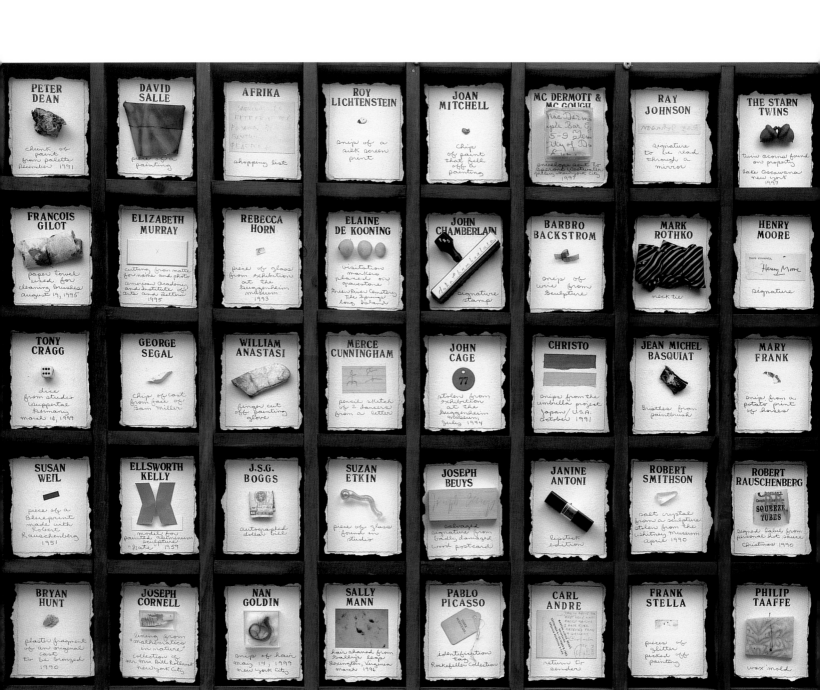

PETER DEAN	DAVID SALLE	AFRIKA	ROY LICHTENSTEIN	JOAN MITCHELL	MC DERMOTT & MC GOUGH	RAY JOHNSON	THE STARN TWINS
chunk of paint from palette December 1991	piece of a painting	shopping list	snip of a silk screen print	chip of paint that fell off a painting	envelope sent to Sperone Westwater gallery New York City 1997	signature to be read through a mirror	twin acorns found on property lake Oscawana New York 1997

FRANCOIS GILOT	ELIZABETH MURRAY	REBECCA HORN	ELAINE DE KOONING	JOHN CHAMBERLAIN	BARBRO BACKSTROM	MARK ROTHKO	HENRY MOORE
paper towel used for cleaning brushes August 19, 1995	cutting from matte for name and photo American Academy and Institute of Arts and Letters 1995	piece of glass from exhibition at the Guggenheim museum 1993	visitation markers placed on gravestone Green River Cemetery The Springs Long Island	signature stamp	snip of wire from sculpture	neck tie	signature

TONY CRAGG	GEORGE SEGAL	WILLIAM ANASTASI	MERCE CUNNINGHAM	JOHN CAGE	CHRISTO	JEAN MICHEL BASQUIAT	MARY FRANK
dice from studio Wuppertal Germany March 18, 1999	chip of cast from face of Sam Miller	finger cut off painting glove	pencil sketch of 2 dancers from a letter	stolen from exhibition at the Guggenheim museum July 1994	snips from the umbrella project Japan / U.S.A. October 1991	bristles from paintbrush	snip from a potato print of boxes

SUSAN WEIL	ELLSWORTH KELLY	J.S.G. BOGGS	SUZAN ETKIN	JOSEPH BEUYS	JANINE ANTONI	ROBERT SMITHSON	ROBERT RAUSCHENBERG
piece of a blueprint made with Robert Rauschenberg 1951	models for painted aluminum "Gate" 1959	autographed dollar bill	piece of glass found in studio	salvaged signatures from badly damaged wood postcard	lipstick edition	salt crystal from a sculpture stolen from the Whitney Museum April 1990	signed label from personal hot sauce Christmas 1990

BRYAN HUNT	JOSEPH CORNELL	NAN GOLDIN	SALLY MANN	PABLO PICASSO	CARL ANDRE	FRANK STELLA	PHILIP TAAFFE
plaster fragment of an original cast to be bronzed 1990	lining from "mathematics in nature" collection of mr. Mrs. Bill Rilevet New York City	snip of hair May 14, 1999 New York City	hair shaved from Sallie's legs Lexington, Virginia March 1996	identification tag Rockefeller collection	return to sender	pieces of glitter picked off painting	wax mold

ARTISTS MUSEUM: A poor man's collection of high-priced artists.

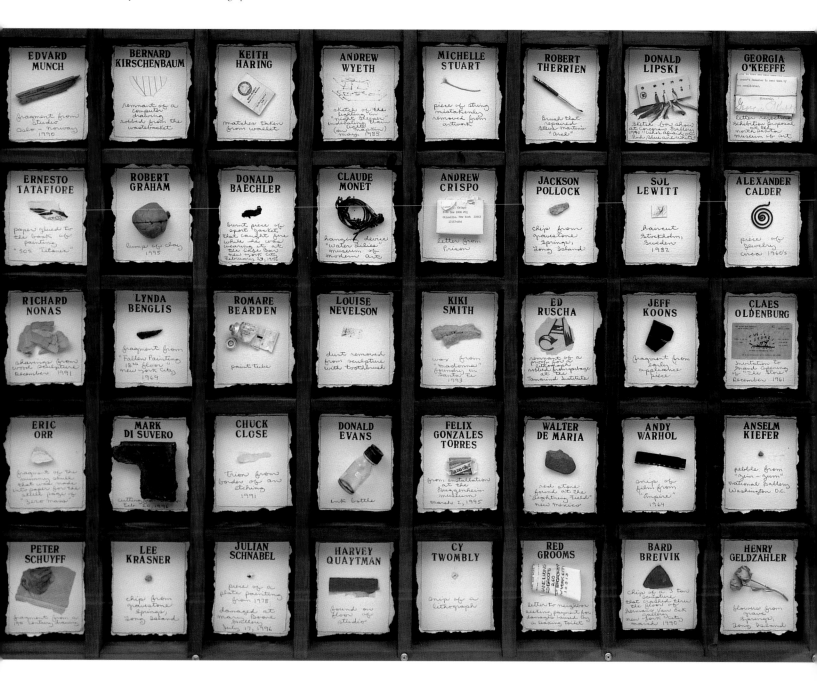

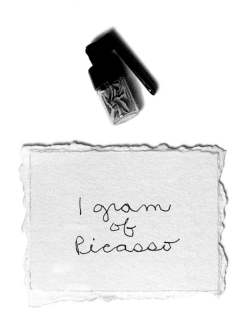

I gram
of
Picasso

I once had an original Picasso lithograph. I say "once" because one night, a little high, I thought I was being very clever and scribbled on the lithograph. When I came to the next morning, I freaked and realized I had destroyed my Picasso. It hung there like a nasty stain on my wall for about a week. I'd paid a lot of money for that lithograph—like so many others I'd wanted a piece of Picasso. Then, either inspiration or desperation made me put it into a blender and grind it up. I got some cocaine bottles and filled them with the Picasso, telling people I was selling Picasso by the gram. After they were all sold, a dealer in Sweden wanted to know if I had any more grams of Picasso. I just had the one left that I was keeping for myself, so I decided to put that little bit back in the blender with some plain paper, and I sold a "cut" Picasso. ¶

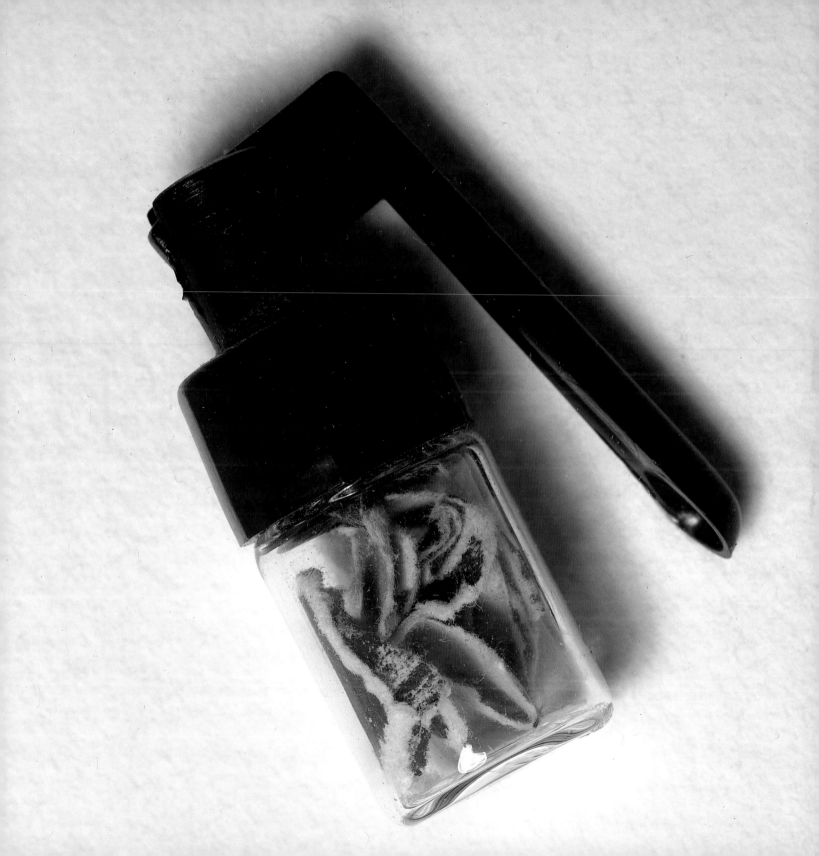

 ROY LICHTENSTEIN
snip of a silk screen print

 JOAN MITCHELL
chip of paint that fell off a painting

MC DERMOTT & MC GOUGH
envelope sent to Berond (Sectwater) gallery New York City 1997

RAY JOHNSON
signature to be read through a mirror

THE STAR TWINS

twin acorns from on property lake Oscawan New york 1997

ELAINE DE KOONING

visitation markers placed on gravestone Green River Cemetery The Springs Long Island

JOHN CHAMBERLAIN

signature stamp

BARBRO BACKSTROM

snip of wire from sculpture

MARK ROTHKO

neck tie

HENRY MOORE

signature

MERCE CUNNINGHAM

pencil sketch of 2 dancers from a letter

JOHN CAGE
stolen from exhibition at the Guggenheim Museum July 1994

CHRISTO

snips from the umbrella project Japan/U.S.A. October 1991

JEAN MICHEL BASQUIAT
Bristles from paintbrush

MARY FRANK
snip from a potato print of Roses

SUZAN ETKIN

piece of glass found in studio

JOSEPH BEUYS

salvaged signature from badly damaged wood postcard

JANINE ANTONI

lipstick edition

ROBERT SMITHSON

salt crystal from a sculpture stolen from the whitney museum april 1990

ROBERT RAUSCHENBERG
signed label for personal hot sauce Christmas 1990

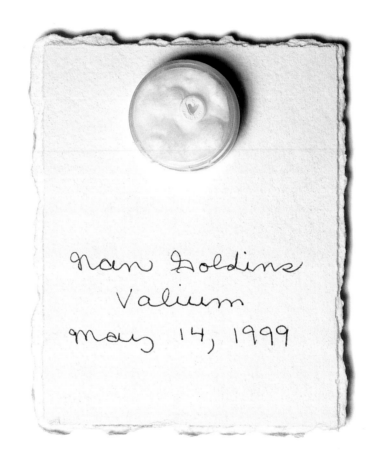

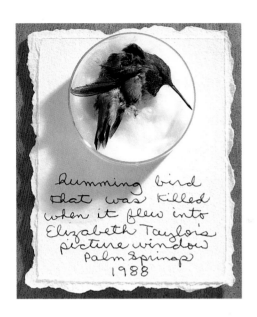

humming bird
that was killed
when it flew into
Elizabeth Taylor's
picture window
Palm Springs
1988

An old roommate and friend of mine moved to Palm Springs and took a job as a letter carrier. One day he sent me a dried hummingbird in a small box. He delivered letters to lots of stars, and this particular hummingbird had crashed into Elizabeth Taylor's window. My friend picked it up and sent it to me with a note asking that I never disclose where I got it. ¶ Evidently letter carriers are not supposed to pick up anything, even off the ground, or they could lose their job. He used to send me all sorts of good stuff. He sent me a dried palm branch from Jim and Tammy Faye Bakker's yard, which I made into eyelashes. He also sent me a piece of Liberace's bedroom carpet (I didn't ask how he got that). He sent me dried flowers from Magda Gabor's garden and even a watermelon seed from Sammy Davis Jr.'s garden. He was living in the house that Sammy Davis Jr. used to live in. I had to swear never to reveal the source of any of these relics. ¶ But two years ago he died, so now I feel free to say where these relics come from. ¶

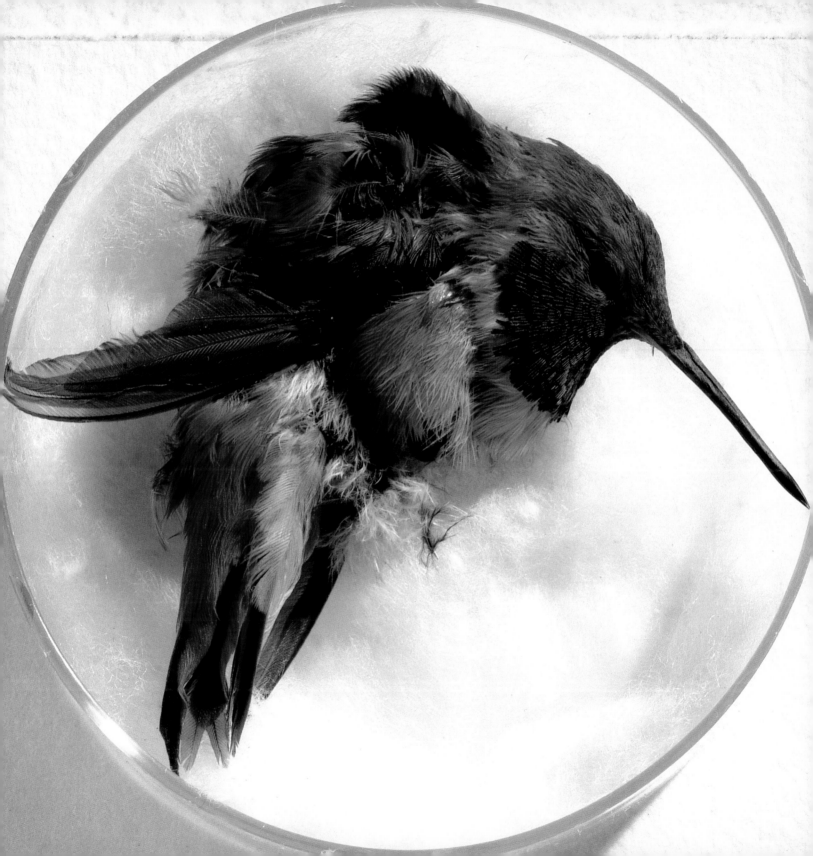

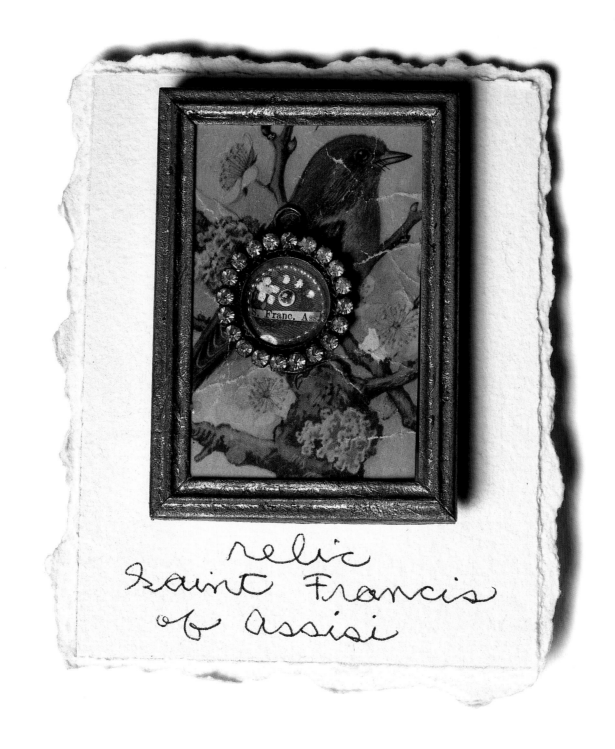

relic
saint Francis
of Assisi

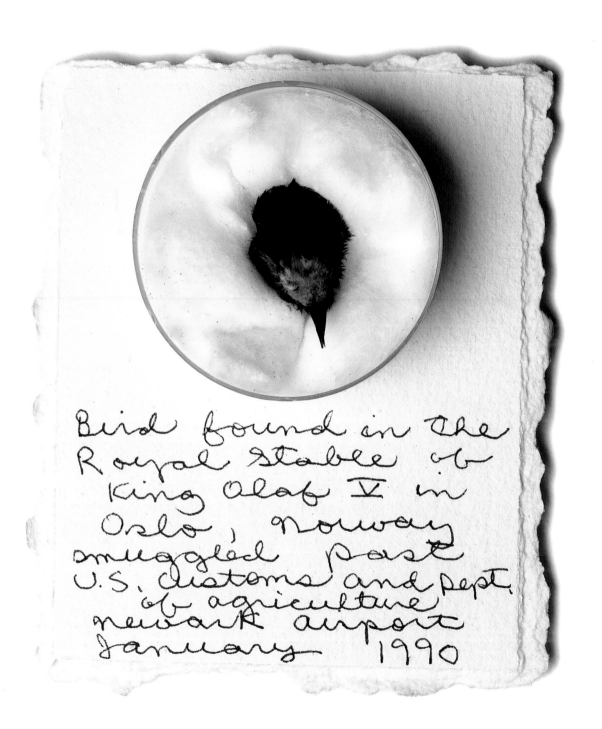

Bird found in the
Royal Stable of
King Olaf V in
Oslo, Norway
smuggled past
U.S. Customs and Dept.
of agriculture
newark airport
January 1990

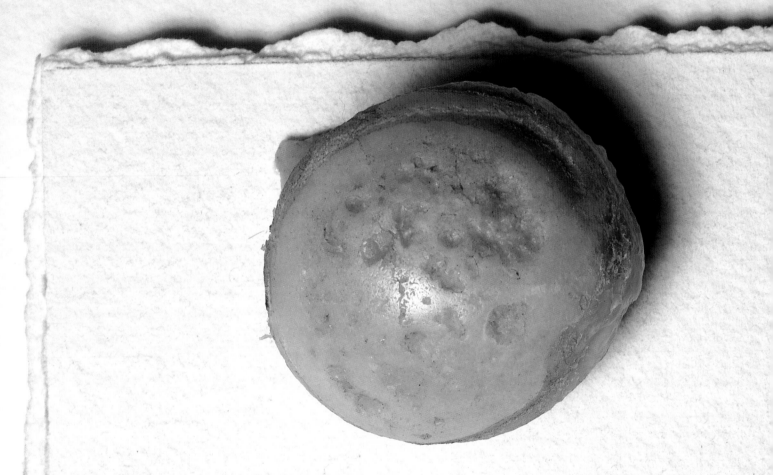

Laurel Reuter's
hip ball from total
hip replacement

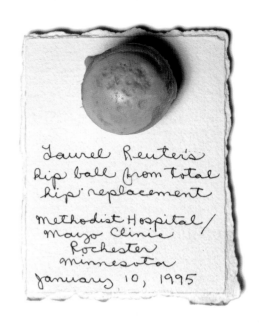

Laurel Reuter's
hip ball from total
hip replacement

Methodist Hospital /
Mayo Clinic
Rochester
Minnesota
January 10, 1995

My friend Laurel was having a double hip replacement, and before she went into the hospital I asked her if I could get a piece of her hip. So, before they wheeled her into the operating room, she made this request to the surgeon. After the surgery, while she was recovering, the surgeon walked into her room and handed her a jar. On my next trip to North Dakota, Laurel handed me this package: I opened it up, and it was her hip ball in a jar—except it hadn't been cleaned. It made my stomach turn, and I told her it was unacceptable. She said she'd delivered it for me, she hoped I didn't expect her to clean it too. Her nephews were in the kitchen cleaning smelly catfish, so I asked them if they could clean this for me, but they ran off, saying it was too gross for them. I thought it would be on the same level as cleaning a catfish. ¶ We had to decide what to do with this hip ball with flesh attached to it, then Laurel had the idea to put it in the yard and cover it with a screen and let the bugs do the work for us. In a few weeks that hipbone was clean and polished with a nice shine to it. I understand why museums keep bugs for the purpose of cleaning things. I sure would like to have a jar of those in my studio. ¶

I have a friend named Bill who lives in the mountains in Virginia. He always has fantastic and bizarre things for me. Every time he comes to New York he brings me some kind of treasure. Anything from road kill to puppy-dog tails. Once he brought me three year's worth of his fingernail clippings, which freaks people out more than other things, although I don't understand why. They are clean. But these fingernails arrived because he couldn't get me what he promised: three amputated fingers from a homeless wino who hangs around downtown Roanoke. The fingers were knurled by the ravages of time, and Bill photographed them and asked "Charlie" if he could purchase the fingers after they were amputated. He said, "Shit yeah, I'll tell the doc at the Vets Hospital to wrap them up for you." Well, time passed and then Bill ran into Charlie sitting on a wall and asked him what the story was with the fingers. He told him that the doctors had loaded him up with antibiotics, which had knocked out his gangrenous-looking condition so there was no need to amputate. But he said they would still have to remove his nails, and Bill told me they were some nails! They looked like they belonged to some kind of galloping anthropoid. He agreed to let Bill have the nails for $2, but in the meantime, while I wait for those, Bill sent me his fingernails. ¶

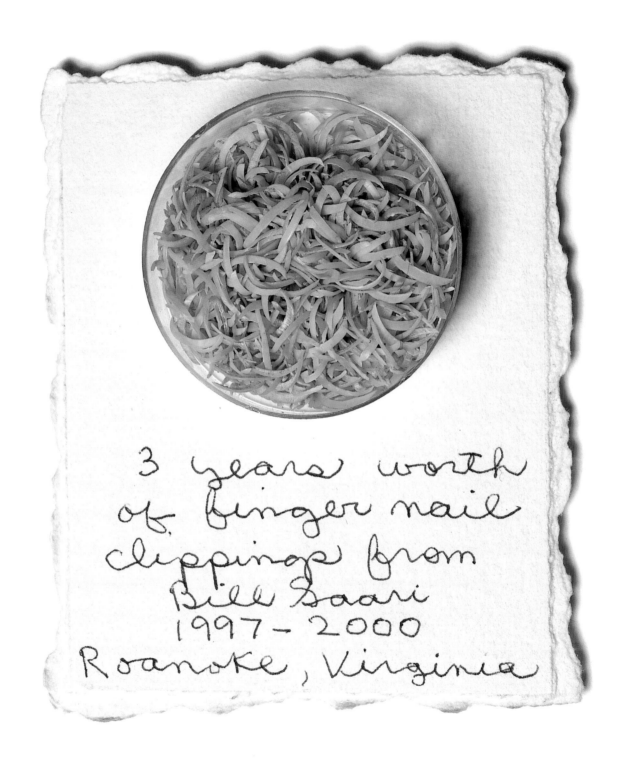

3 years worth
of finger nail
clippings from
Bill Saari
1997 - 2000
Roanoke, Virginia

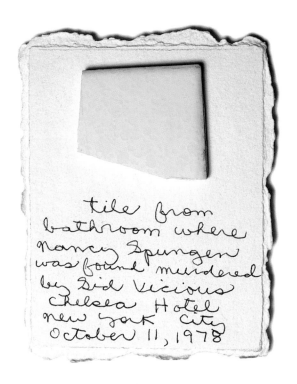

tile from
bathroom where
Nancy Spungen
was found murdered
by Sid Vicious
Chelsea Hotel
New York City
October 11, 1978

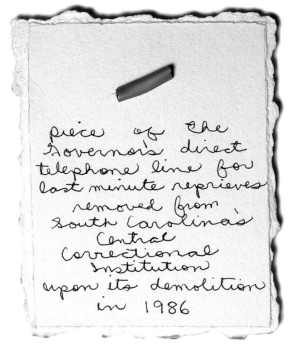

piece of the
Governor's direct
telephone line for
last minute reprieves
removed from
South Carolina's
Central
Correctional
Institution
upon its demolition
in 1986

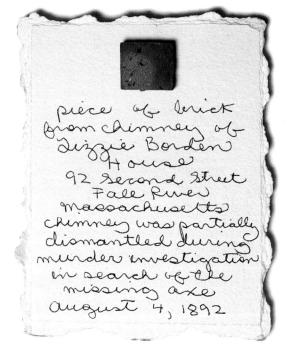

piece of brick
from chimney of
Lizzie Borden
House
92 Second Street
Fall River
Massachusetts
chimney was partially
dismantled during
murder investigation
in search of the
missing axe
August 4, 1892

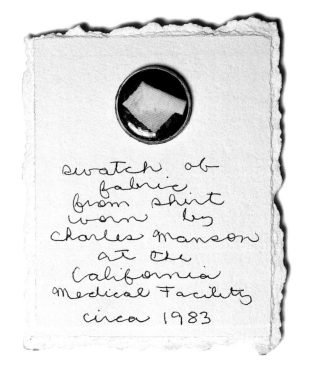

swatch of
fabric
from shirt
worn by
Charles Manson
at the
California
Medical Facility
circa 1983

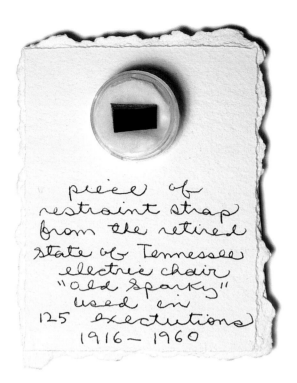

piece of
restraint strap
from the retired
state of Tennessee
electric chair
"Old Sparky"
used in
125 executions
1916 – 1960

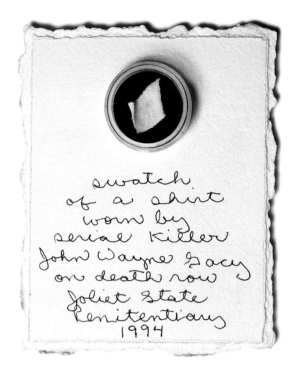

swatch
of a shirt
worn by
serial killer
John Wayne Gacy
on death row
Joliet State
Penitentiary
1994

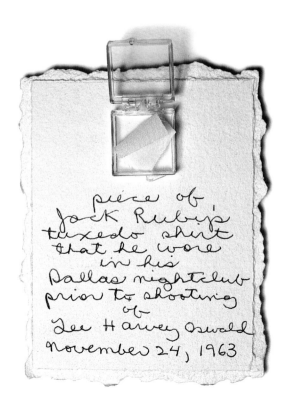

piece of
Jack Ruby's
tuxedo shirt
that he wore
in his
Dallas nightclub
prior to shooting
of
Lee Harvey Oswald
November 24, 1963

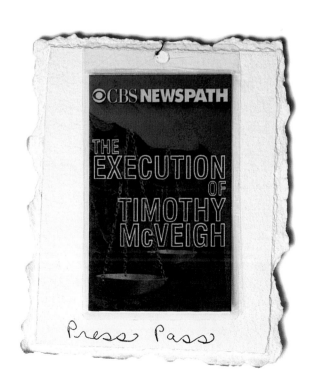

Press Pass

Philip Borden's permanent bridge found in his cremation ashes Palm Springs California Feb 20, 1996

Death Squad medallion Rio de Janeiro Brazil 1991

coroners patch

Bone fragment from the leg of an Egyptian mummy circa 1000 BC.

Mount Olivet Cemetery Maspeth, New York died for two adult graves

Zombie powder from a sorcerer Haiti 1985

mummy wrapping from the mummy of Yuya the father of Queen Tiy 18th Dynasty 1400 B.C.

last rites ring

Wanted by FBI Wardell David Ford for murder

Maria Torg Halpert Katz born: Sept. 1, 1893 gassed at Auschwitz May 31, 1944

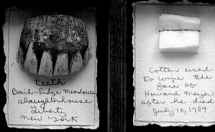

teeth Bald-Ridge Meadows slaughterhouse Liberty New York

Cotton used to wipe the face of Howard Meyer after he died July 10, 1989

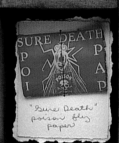

"Sure Death" poison fly paper

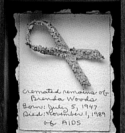

Cremated remains of Brenda Woods Born: July 5, 1947 Died: November 1, 1989 of AIDS

piece of fringe from the Duke of Wellington's coffin 1852

Undertakers wound filler

Rose Petals from the village of Lidice, Czechoslovakia destroyed by the Nazis in 1942

letter from Betty Bebalow whose body was found under melting snow in Switzerland, chopped into little pieces and put into two garbage bags 1978

water from Pearl Harbor

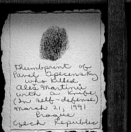

Thumbprint of Panel Specensky who killed Ales Martinu with a knife (in self-defense) March 21, 1991 Prague Czech Republic

morticians needles

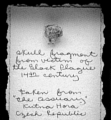

skull fragment from victim of the Black Plague 14th century taken from "the assuary" Kutna Hora Czech Republic

Democratic Campaign for coroner

embalming fluid Royal Superior Cosmetic afterglow

Tibetan Yak bone tantric skull

embalming eye caps

Mark David Chapman autograph 1993 (Killed John Lennon)

seal to the crypt of the falcon mummies at Saqqara Egypt

lump of stuff from floor of grave in church at the Holy Sepulcher Jerusalem

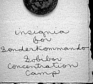

insignia for Sonderkommando Sobibor Concentration Camp

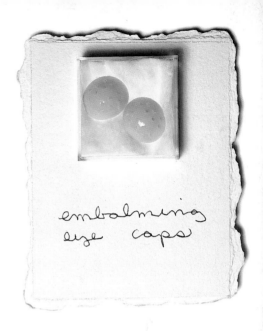

embalming
eye caps

A friend of mine gave me an embalmer's makeup case, and these eye caps were in it. They are placed over the eyeballs, and the eyelids are pulled over them. Their sharp surface prevents the eyelids from opening up. ❡

DEATH MUSEUM (detail): A collection of the macabre, of death and disease, heinous crimes, embalming, and the afterlife.

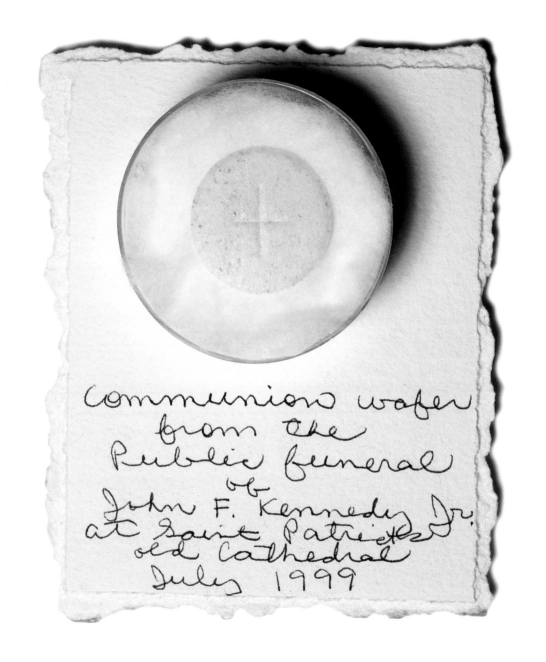

Communion wafer
from the
Public funeral
of
John F. Kennedy Jr.
at Saint Patrick's
old Cathedral
July 1999

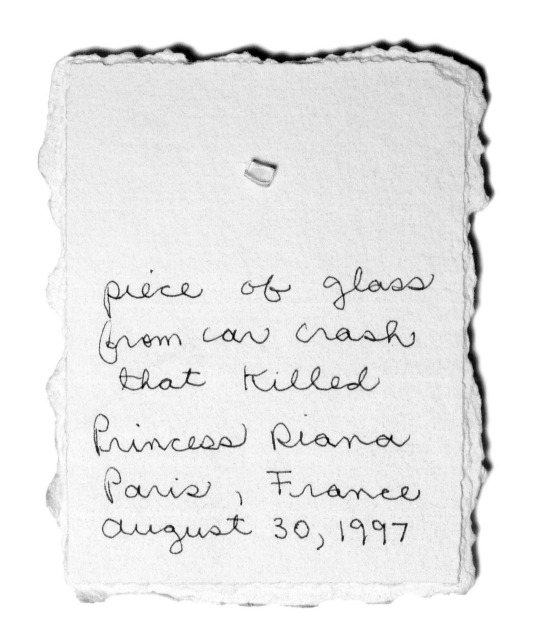

piece of glass
from car crash
that killed
Princess Diana
Paris, France
august 30, 1997

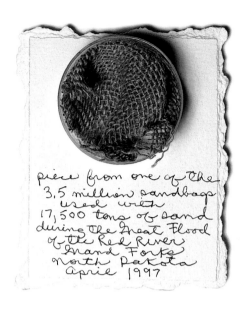

piece from one of the 3.5 million sandbags used with 17,500 tons of sand during the Great Flood of the Red River Grand Forks North Dakota April 1997

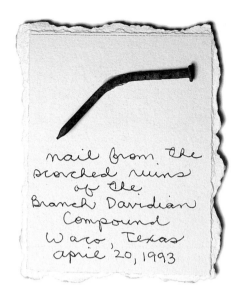

nail from the scorched ruins of the Branch Davidian Compound Waco, Texas April 20, 1993

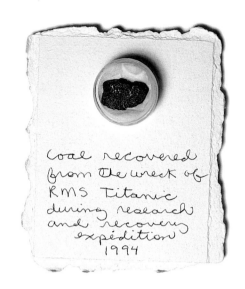

coal recovered from the wreck of RMS Titanic during research and recovery expedition 1994

There was a terrible flood in North Dakota in 1997. The Red River devastated the town of Grand Forks. The North Dakota Museum commissioned me to make a "Flood Wall" at the museum, and the local newspaper ran a story asking everybody to bring something from the flood for the installation I was doing. Everything had to have a story to go with it. I built a huge piece about 35 feet long with lots of cubbyholes. I only use fragments of most things, so I got a lot of good stuff for myself too. Someone brought in one of the 3.5 million sandbags that had been used with 17,500 tons of dirt. The stories that accompanied the relics were wrenching. One woman sent me her cat's toy—the cat had perished in the flood. Another woman brought the wheel of her car—she saved her whole life to buy it, and the wheel was all she had left. Someone brought a new Christmas ornament, and I asked her why. She said that she lost all her ornaments and this one was from the batch of new ones she had bought. Someone brought a trumpet that he found on top of a tree. The mayor gave me the button from the dress she wore when Clinton came to Grand Forks, the only dress she had left. This was my first "planned collaboration." Everybody participated, and it was wonderful when they opened the show to the public. Many of these people had never been in a museum, and now they

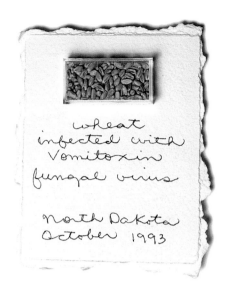

wheat
infected with
Vomitoxin
fungal virus

North Dakota
October 1993

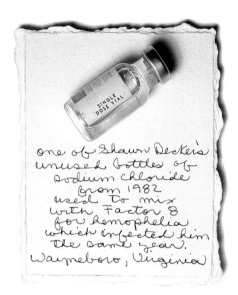

one of Shawn Decker's
unused bottles of
sodium chloride
from 1982
used to mix
with Factor 8
for hemophelia
which infected him
the same year.
Waineboro, Virginia

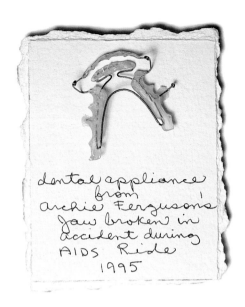

dental appliance
from
Archie Ferguson's
jaw broken in
accident during
AIDS Ride
1995

were part of the collection. It was one of the most incredible experiences of my life. Everybody caught on. It was a wall of memories. ¶ I was putting together a collection of AIDS memorabilia for an exhibition for the World AIDS conference, and one of the writers at POZ *Magazine* sent me this bottle of sodium chloride mixed with Factor 8, which is used to treat hemophilia. He was infected with the HIV virus from using this, so he kept a bottle as a souvenir of the event. ¶ I was visiting friends on Fire Island a week or two after the crash of TWA Flight 800 and one day, as I was walking along the beach, I noticed some strange stuff mixed in with the seaweed that had been washed in by the tide. There was a lot of it, and I picked up a few pieces. It turned out to be burnt insulation from the plane. Then a neighbor told me that I could go to jail for picking this up. She said this tiny little piece could hold the answer to why the plane went down. I became really paranoid and wrapped the little fragments in aluminum foil and hid them behind some books in my studio. I had nightmares about the FBI coming to get me. I waited a long time before I got over that fear, and now I've finally used the fragment. ¶ I was collecting relics from disasters to make a museum. I researched newspaper archives about these disasters and collaged the museum frame with the articles I found. I put

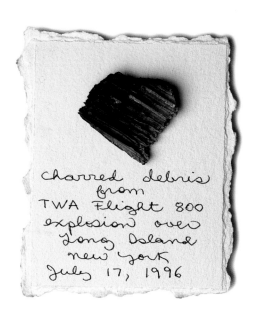

charred debris from TWA Flight 800 explosion over Long Island New York July 17, 1996

the word out, and before I knew it disasters were filling my mailbox. The Vomitoxin fungal virus, which destroyed the wheat crops in North Dakota, was sent to me by two friends of mine who live there. One day I was at lunch with some people and met a guy whose aunt had been trapped under the collapsed freeway for twenty-two hours after the earthquake in San Francisco. He gave me some of the debris from the freeway that they had to chop away to get his aunt out of the car. ¶ I usually don't buy relics, since part of the process is having the relics arrive randomly, but once in a while there is something I can't resist. I've bought some things at auctions, such as the trinitite, which is fused sand from the first atom bomb blast, and a bunch of nails from the ashes of the Branch Davidian Compound. ¶ My friend Archie was participating in an AIDS Ride and had a terrible bike accident. He was taken to the hospital with broken bones, a broken jaw, and broken teeth. He gave me the mouthpiece he had to wear after the accident. ¶

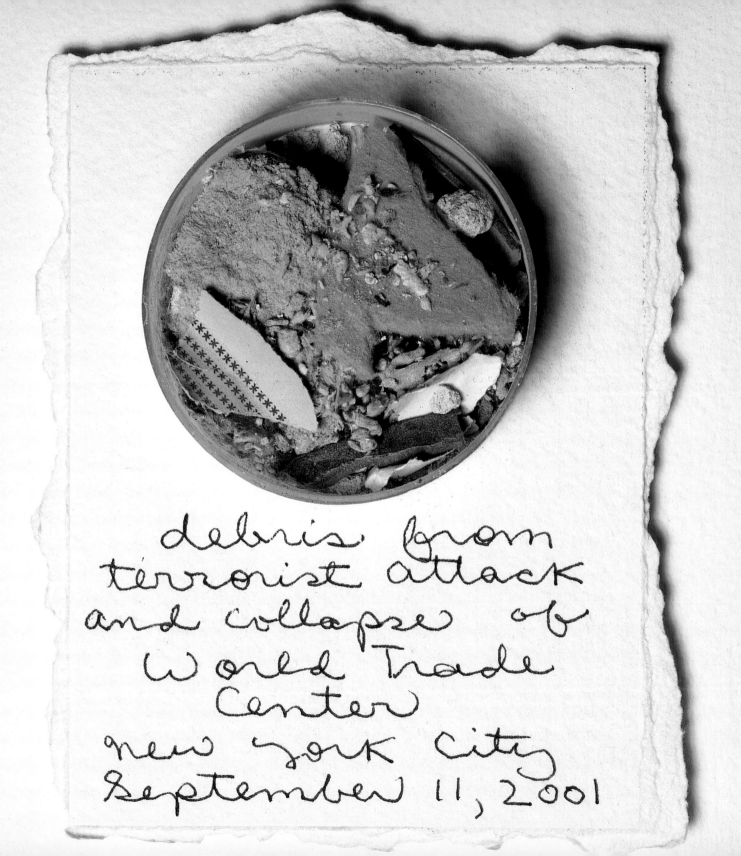

debris from
terrorist attack
and collapse of
World Trade
Center
new york City
September 11, 2001

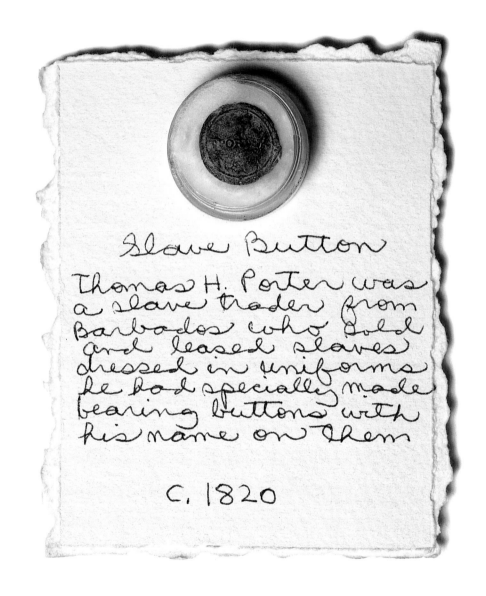

Slave Button

Thomas H. Porter was
a slave trader from
Barbados who sold
and leased slaves
dressed in uniforms
he had specially made
bearing buttons with
his name on them

C. 1820

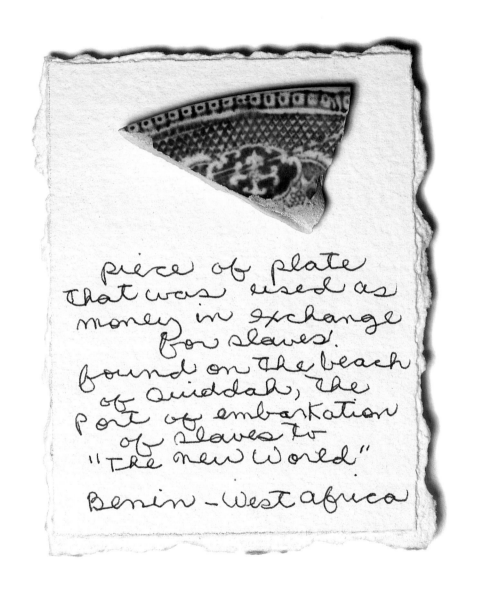

piece of plate
that was used as
money in exchange
for slaves.
found on the beach
of Quiddah, the
port of embarkation
of slaves to
"The new World."

Benin - West Africa

twig from a broom
that swept the room
that Mao Tse Tung
used as a student
at Human University
from 1917 - 1919
Changsha - China

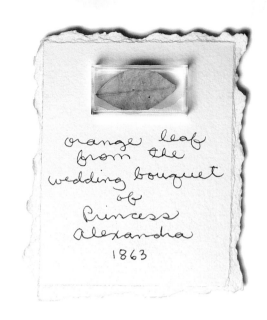

orange leaf
from the
wedding bouquet
of
Princess
Alexandra
1863

Friends who are collectors of my work were visiting China, and they brought me back one of my very favorite relics. The description is poetry, "twig from a broom that swept the room that Mao Tse Tung used as a student at Hunan University from 1917 to 1919." They were left alone in this room for a few minutes and if you met this couple, it would be hard to imagine them stealing something from the room, and something so trivial, but they did. They picked a twig off the broom. I can only imagine what would have happened if they were caught. ❡

grass and wildflowers
from the spot where
Christina is positioned
in Andrew Wyeth's
"Christinas World," 1948
Cushing, Maine

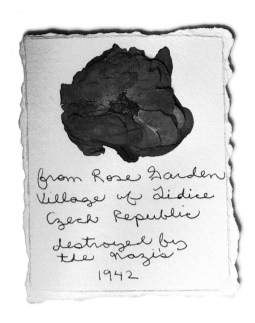

from Rose Garden
Village of Lidice
Czech Republic
destroyed by
the Nazi's
1942

While I was on that same trip in the Czech Republic, I was taken to see the village of Lidice, which I am named after. I was born the same year that the Nazis destroyed the town in retaliation for the assassination of a German officer. All the men were shot dead, and the women and children were sent to concentration camps. Then the village was completely destroyed so that nothing remained of it. Hitler said " Lidice is dead," and when I was born my father gave me that name and said, "Lidice lives." I never realized what a heavy name I was carrying around all my life, but after seeing that place I was proud to have the name. There is a museum there with "relics" from the town. It looked as though it was something I would make. Where the town once stood is an enormous rose garden planted in the memory of all the people who were killed. I had to have a rose, no question about it. But I had to pick it when nobody was looking, and there were all these *babickas* working in the garden, as well as lots of tourists. I found the right moment and cupped the rose and used my fingernails to cut it, not an easy task. A thorn cut the palm of my hand, making it bleed. I quickly put the flower in my pocket, and while I was doing it, I felt a sharp sting. There was a bee on the rose. Cut and stung. I did manage to bring the rose back to the States intact, and pressed it, and now have it in my relic case of flowers. ❡

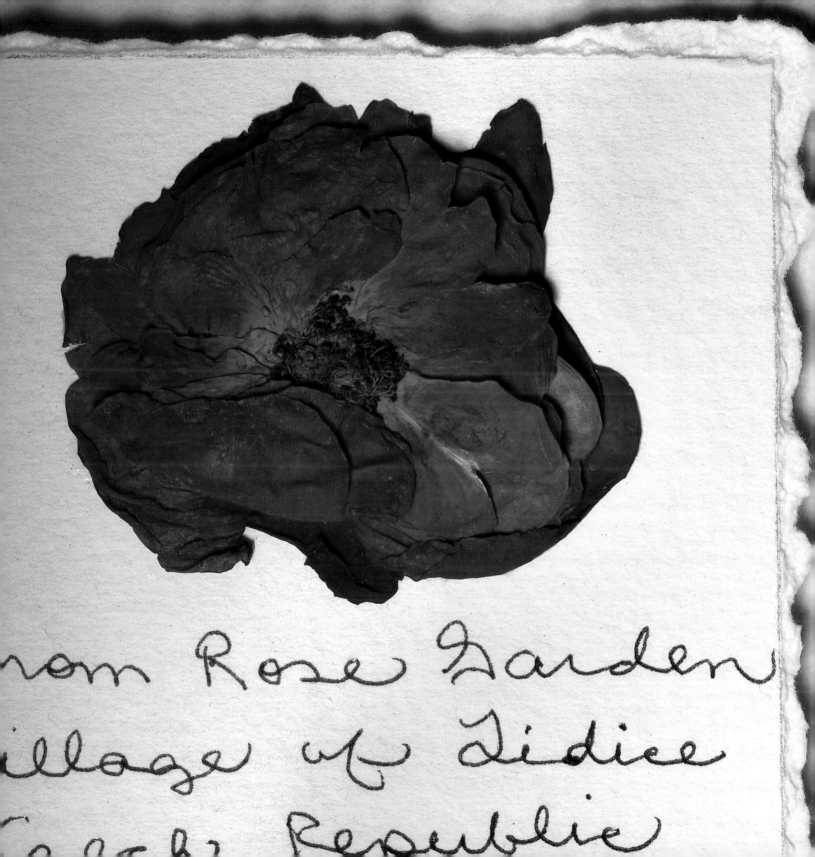

from Rose Garden
Village of Lidice
Czech Republic

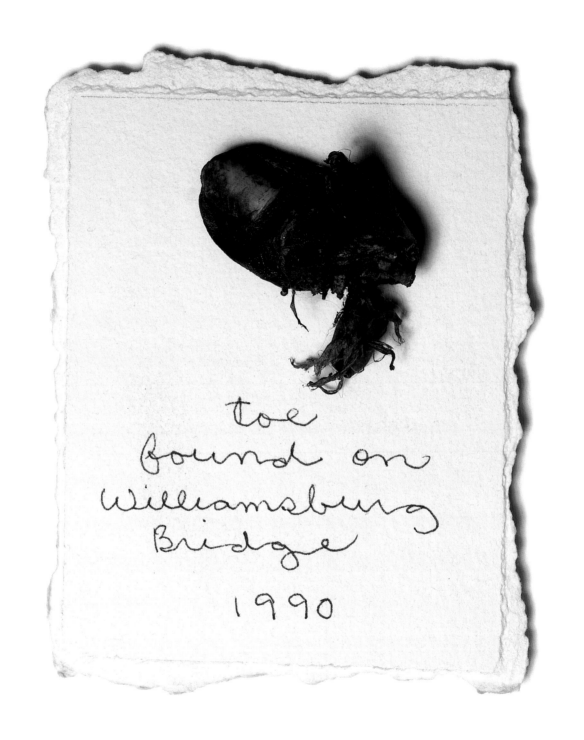

toe
found on
Williamsburg
Bridge

1990

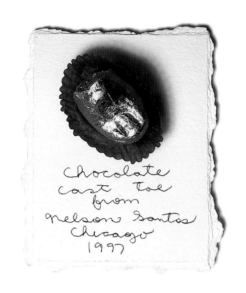

Chocolate
cast toe
from
Nelson Santos
Chicago
1997

A friend of mine was visiting from Prague, and was walking across the Williamsburg Bridge. He telephoned me and said that he had found a toe, and asked me if I would like it. I asked him if it smelled, and he said he wasn't going to smell it, so I said okay and took my chances. ¶ He brought it over here, and it certainly was a toe, dried and mummified. It took me months before I could take it out of the plastic envelope—it was just too icky looking, and I was afraid of germs. When I finally worked up the nerve, I put on several rubber gloves and mounted it on a card. Then I put it in one of the cubbyholes and left it. ¶ Several weeks later I noticed something strange about the toe. It looked like it was moving. I put on my glasses and saw that it had maggots. Evidently a fly had landed on it and left me this gift. I freaked and didn't know what to do. So I called a doctor friend at Sloan-Kettering, and she said to throw the toe out! I said I couldn't because I would never find another one. I decided to call my Egyptologist friend, who said "Put it in the freezer, and that will kill anything on it." So I did that, and it worked! ¶ But, just to make sure, I bought a can of Tat, a bug spray, and I sprayed the entire contents of the canister on the toe. And nothing's gonna live there now. ¶ My friend Nelson Santos came to dinner one night with a bouquet of flowers and chocolate. It was his toe cast in chocolate and wrapped in gold foil. ¶ The toe from the Williamsburg Bridge found a mate! ¶

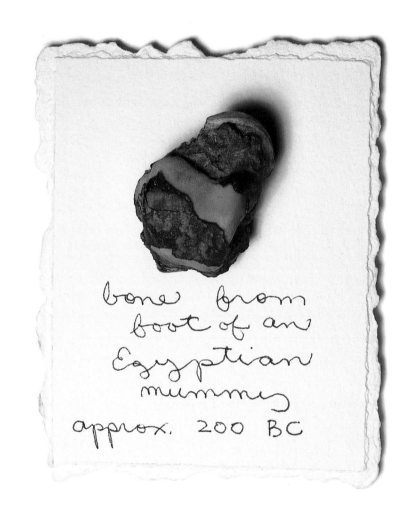

bone from
foot of an
Egyptian
mummy
approx. 200 BC

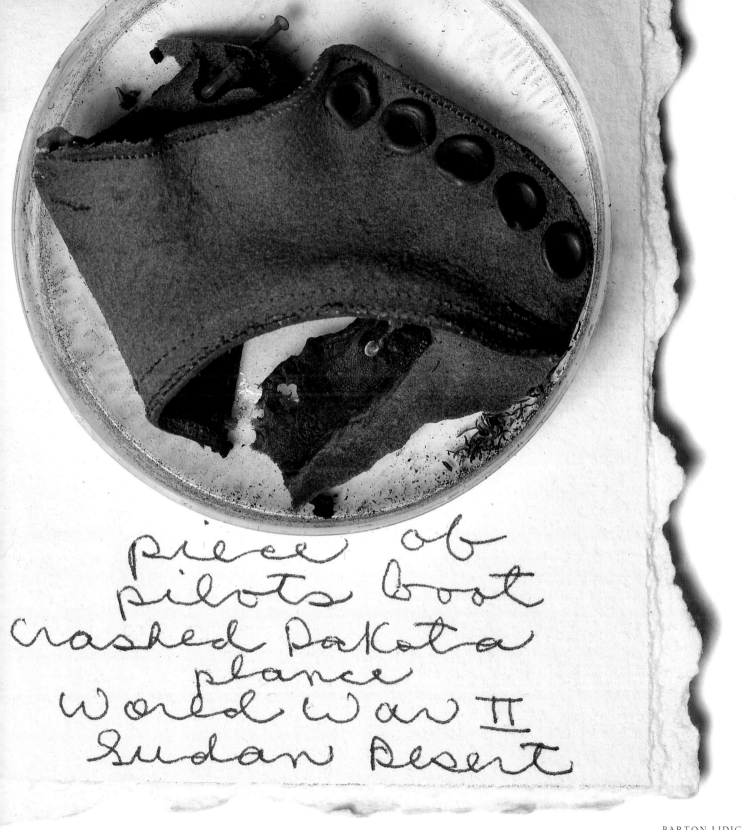

piece of
pilots boot
crashed Dakota
plane
World War II
Sudan Desert

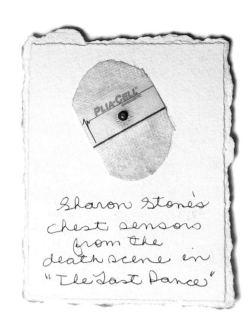

Sharon Stone's
chest sensors
from the
death scene in
"The Last Dance"

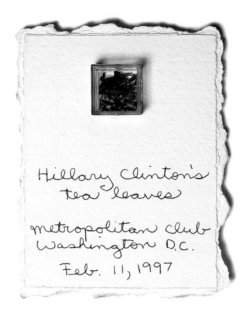

Hillary Clinton's
tea leaves

Metropolitan Club
Washington D.C.
Feb. 11, 1997

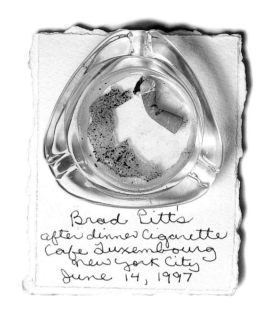

Brad Pitt's
after dinner cigarette
Café Luxembourg
New York City
June 14, 1997

One day I went to my mailbox and found a large envelope. I opened it and found another envelope inside, which read, "Please send this to Barton Beneš. His address is in the book. Thanks." ¶ I opened the second envelope and found two medical patches, like those used for cardiograms. The message said, "My chest sensors from the death scene in *The Last Dance*." There was no other message, but looking at the return address, I recognized that it was Sharon Stone's. ¶ Larry Hagman is a good friend of mine, and he was having a liver transplant. We were all concerned, and I was watching CNN for coverage. When his surgeon came out for a press conference to report that Larry's operation went very well, I got a surprise. He told the world that Larry wanted to give his gallstones to his artist friend Barton Beneš to make art out of them. This was the first I had heard about it. And the first that many of the nutcases in the world heard about me. The phone rang and rang. So I received this relic in a press conference on CNN. How is that

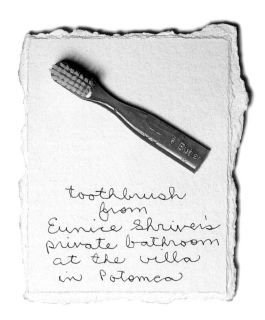

toothbrush
from
Eunice Shriver's
private bathroom
at the villa
in Potomea

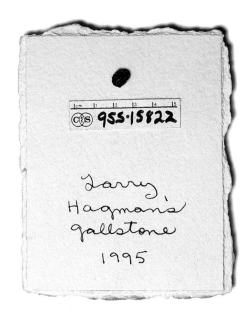

C▢S 955·15822

Larry,
Hagman's
gallstone

1995

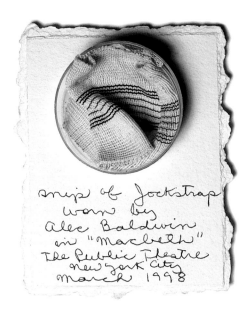

snip of jockstrap
worn by
Alec Baldwin
in "Macbeth"
The Public Theatre
New York City
March 1998

for documentation? ¶ My mother had a ring with a missing diamond. And I replaced it with Larry's gallstone and gave it to him as a gift. ¶ I have two friends who are always good for Clinton relics because they are friends of theirs and contributors. Hillary Clinton's tea leaves are just one of many. I never did ask them how they got the tea leaves out of the tea cup without being noticed. I have so many friends who put their reputation on the line by sneaking away these relics for me. I know someone who used to be a waiter at Cafe Luxembourg, and he would get me fantastic relics for my food museum, including Brad Pitt's after-dinner cigarette in its ashtray. My friend was always very nervous that he would get caught—he would hide these things in his locker, and then wait until the coast was clear to get them out of the restaurant. Waiters are a really good source for stuff, and so are people who work in the wardrobe in the theater. I get lots of items worn by actors, including a jockstrap worn by Alec Baldwin. ¶

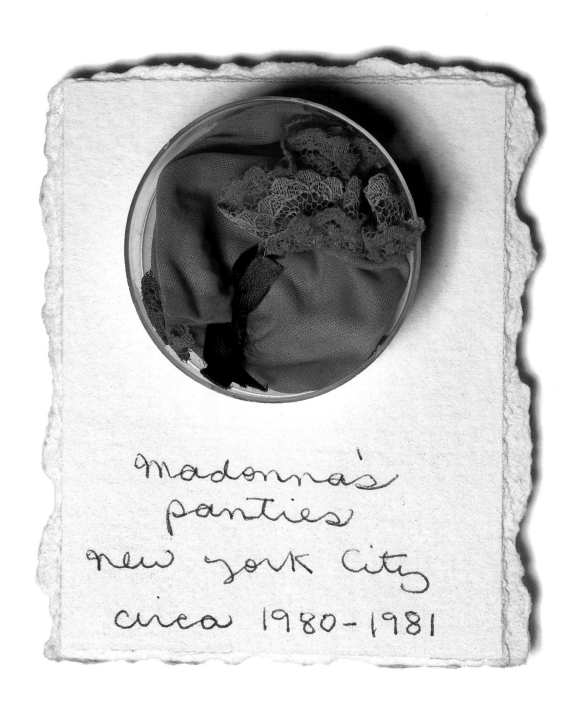

madonna's
panties
new york city
circa 1980-1981

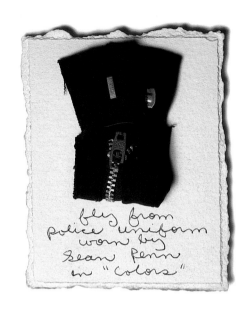

fly from
police uniform
worn by
Sean Penn
in "Colors"

Someone died in my building who was a musician and worked with Madonna. There was an apartment sale of his belongings. One of the items for sale was Madonna's panties. I bought them for only ten dollars. There were other neighbors there and they looked at me and asked what I was going to do with them. I said I was going to use it in my art, and they all looked at me strangely, probably thinking that I was going to get off wearing them. Not long after, Annie Flanders asked me to make a patch for the AIDS quilt and wanted to know how much money I wanted for it. I said I didn't want anything, and after I made the patch for her she gave me the suit worn by Sean Penn in *Colors*. I brought it home and cut the fly out of the crotch. This was the perfect companion piece for the panties. A diptych reliquary. It is one of the most popular relics that I have, everybody wants to touch them. ❡

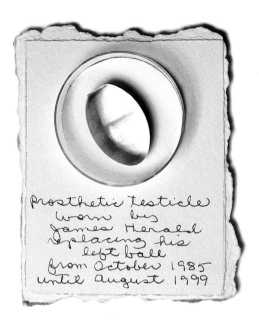

prosthetic testicle worn by James Herald replacing his left ball from October 1985 until August 1999

My friend Jim called me up and asked me if I wanted his "left ball." I wasn't quite sure what he was talking about, but was hoping it was really his own ball. So I said yes, without inquiring further, and it arrived. But, sure enough, it was a prosthesis. He had had an illness a while back and had to have a silicone ball put in. Then, that particular ball started to leak, the same way breast implants do, and he had to have it replaced, and I am the lucky recipient. ❡

Following pages. CELEBRITY MUSEUM (detail): We are a society that worships celebrity. This is a reliquary for our modern-day saints.

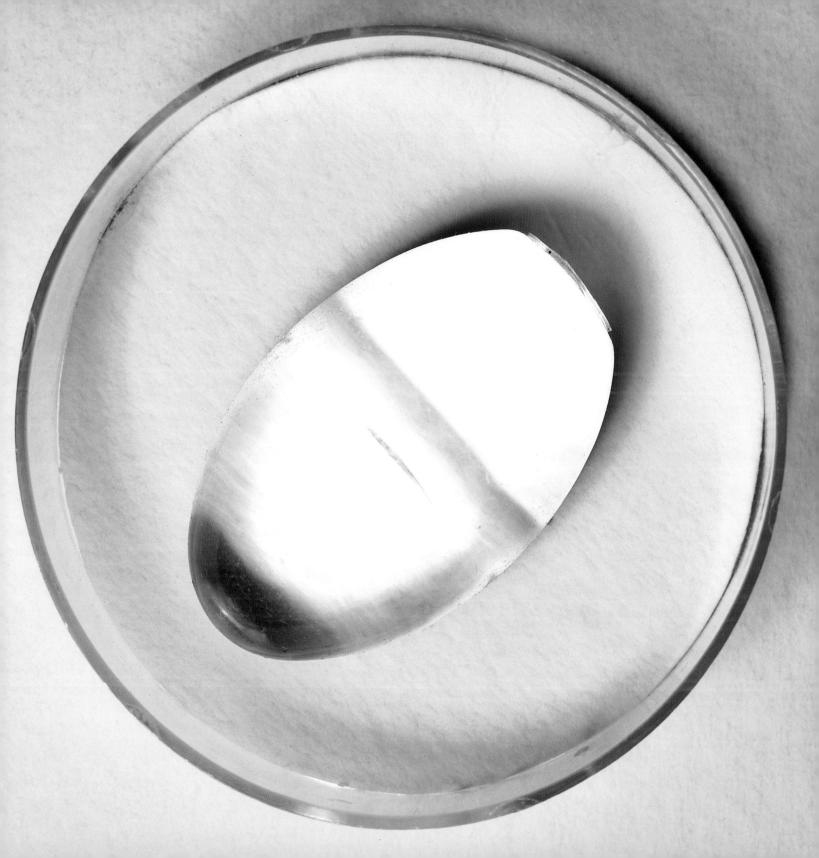

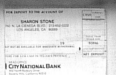

penny
found in
Cyndi Laupers
car
Cape Cod
1990

snip from
leg of panty hose
worn by
Isabella Rossellini
in "Big Night"
1995

thread of gold
from cloth
given by
Ali Khan
to a
woman friend
circa 1959

toy left on beach
in Malibu Colony
by John McEnroes
son
1989

Sharon Stone's
lipstick
on Bank
deposit slip
1993

Baby
announcement
design
rejected by
Diana Ross
August 1971

make-up sponge
used on
Bill Clinton
Fox Television
1992

Sean Penn's
police badge
from the movie
"Colors"

Liz Smith's
gossip for
Good Day New York
Fox TV
November 9, 1993

Dustin
Hoffman's
chewing gum
Los Angeles
"In a new light"
1993

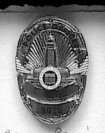

thread from
ballet slipper
of
Mikhail
Baryshnikov

feather
from bird
Burgess
Meredith
feeds at his
Malibu Beach
home
1994

Business card handed
to Brooke Shields
while dining at
Il Fornaio
in Santa Monica
which she tore up
when she left table
April 11, 1999

George
Burns
Cigar
Ren-Mar studio
Hollywood
1988

ANTI-WORM

Robin Leach's
"anti-worm mix"

Marie Osmonds
drawing over a
Keno Ticket
Caesars Palace
Atlantic City
December 12, 1996

Tissue
used to wipe
Michael Jacksons
mouth at the
dental office of
Dr. Lee Baxley
Beverly Hills
Dec 1, 1998 2:15 P.m.

pins used on
a sleeve
alteration for
Robert De Niro
in
"Great Expectations"

Lillian
Gish

laundry tag

Dirt from
Doctor Ruth's
property on
Lake Oscawana
New York
1993

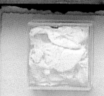

 Eddie Rabbit's
guitar string
Las Vegas
November 1985

 Roy Rogers Snot
in Nasal Douche
Desert Knolls
Pharmacy
Apple Valley
California
Feb. 13, 1969

Birdseed
from
David Geffen's
parrot
Malibu 1994

 Oxygen tube
used by
Ace Frehley
of
"Kiss"

 Fragment
from
Shirley Temple's
doll house
Los Angeles
1990

 Warren Beatty's
pear core
Carlyle Hotel
Dining Room
October 8, 1994

 Tape off of
Woody
Harrelson's
white
Ford
Truck
1994

 Wire from
room 100 at the
Chelsea Hotel
where
Sid Vicious
killed
Nancy Spungen
New York City
1978

 Ronald Trump's
toilet paper
The Trump Tower
New York City
October 3, 1986

JOAN CRAWFORD
 letter from
Joan Crawford
to
Michaele Volbracht

 Yoko Ono's
cigarette butt
New York City
1987

 Barbara Walters'
questions for
Robin Givens
and
Mike Tyson
Interview
20/20 — 1988

 Hal Prince's
glass from the
opening night party
for "Showboat"
October 2, 1994

H G
Dec. 1997
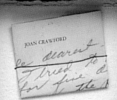 Tag
from one of
Hugh Grant's
shirts
in
"Mickey Blue Eyes"
1997

 Linda
Gray's
rosaries

 Snap from
Joe Namath's
New York Jets
Jacket
1979

 Page out of
Princess Di's
"Hello Magazine"
that she dog-eared,
left in room at
Martha's Vineyard
where she stayed in
1994

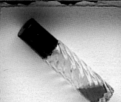 Sylvester Stallone's
wine
Drai Restaurant
Los Angeles
November 1996

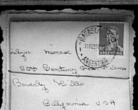 letter to
Marilyn
Monroe
Feb. 21, 1957

manure from
Lindsay Wagner's
horse
Malibu 1994

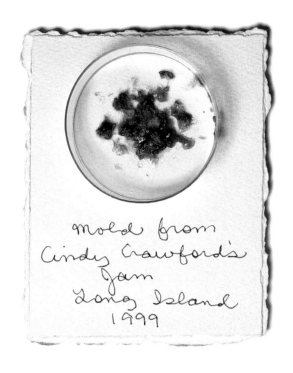

Mold from
Cindy Crawford's
Jam
Long Island
1999

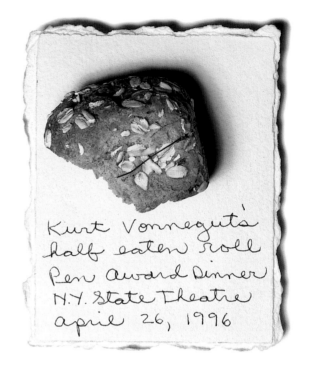

Kurt Vonnegut's
half eaten roll
Pen Award Dinner
N.Y. State Theatre
April 26, 1996

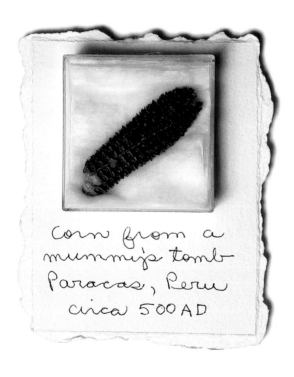

Corn from a
mummy's tomb
Paracas, Peru
circa 500 AD

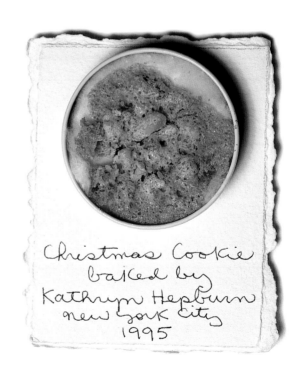

Christmas Cookie
baked by
Kathryn Hepburn
New York City
1995

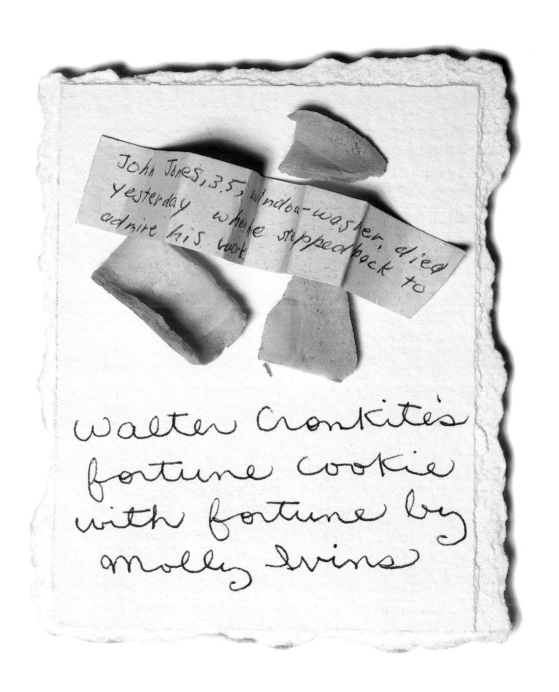

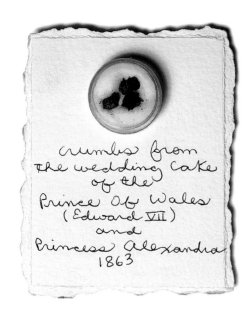

crumbs from
the wedding cake
of the
Prince Of Wales
(Edward VII)
and
Princess Alexandra
1863

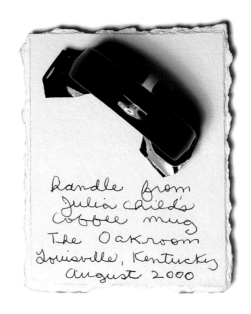

handle from
Julia Child's
coffee mug
The Oakroom
Louisville, Kentucky
August 2000

My dear friend Jeffrey was a collector of wonderful and bizarre things. He also was the editor of *Arts & Antiques* magazine. I was visiting him once, and he showed me what was left of a piece of cake from the wedding of the Prince of Wales and Princess Alexandra in 1863. I asked if I could have some, and he gave me three crumbs. Months later I begged for more crumbs from the wedding cake, but he told me that three crumbs were plenty, and there would be no more. Needless to say, I was very disappointed with his stinginess. After Jeffrey died, his sister had me come over, and gave me a piece of paper with instructions on where to find various items he wanted me to have.

It was like a treasure hunt. And to my surprise, in the bottom drawer next to his bed was the box containing the rest of the cake. ¶ My brother was on a business trip in Kentucky, and one morning when he was having breakfast in his hotel, he noticed that Julia Child was sitting across the room from him. He had his eye set on her coffee cup, thinking of me. He hung around eating very slowly, drinking many cups of coffee, waiting for her to finish. As soon as she did, he got up and made it to the table before the waitress came to clean it, and put the coffee cup under his jacket. A food museum certainly would not be complete without something from Julia. ¶

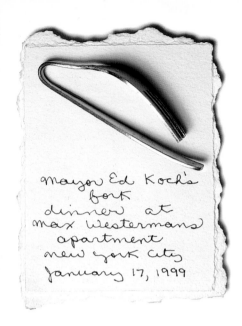

Mayor Ed Koch's fork dinner at Max Westermans apartment New York City January 17, 1999

I was at a dinner party and one of the guests was Mayor Ed Koch. So, after dinner I uncharacter-istically volunteered to help clear the dishes from the table. Between the dining room and the kitchen, I picked up Ed Koch's food-encrusted fork. I simply bent it in half and put it in my pocket. ¶ When I returned to the table for dessert and sat down, to my horror the tips of the fork tore right through my pants. Fortunately, I managed somehow to play it cool until my hasty exit. No one knew of my theft until I included it in my museum of "sharp things" at Lennon Weinberg Gallery. The gallery later received a letter from Koch—who had come to see the show—saying "I never expected to be a relic so early in life." ¶

EDWARD I. KOCH
1290 AVENUE OF THE AMERICAS
NEW YORK, NEW YORK 10104

June 7, 1999

Jill Weinberg Adams
Lennon, Weinberg, Inc.
560 Broadway, Suite 308
New York, New York 10012-3945

Dear Ms. Adams:

Thank you for your May 27th note. I never expected to be a relic so early in life.

All the best.

Sincerely,

Edward I. Koch

 Agnes de Mille's scarf with some spill Russian Tea Room New York 1968

 Kurt Vonnegut's half-eaten roll from Award dinner NY State Theatre April 26, 1996

Birthday candle from Wavy Gravy's 60th birthday Berkeley California May 15, 1996

 Alan Dershowitz's crouton Martha's Vineyard Summer 1996

 "Larvets" BBQ Insect Larva

Salt Peter

 Jessye Norman's cracker President Clinton's birthday party New York City August 18, 1992

Watermelon seed from the window of Sammy Davis Jr. Palm Springs California

Sandra Bernhard's sugar Bus Stop Cafe New York City September 18, 1996

 Cherry stem tied into a knot by Charles Joplin's tongue without the use of his hands June 16, 1996

Bronx Shubb green tomato Santa Monica April 11, 1999

Happy Rockefeller's dinner napkin Rockefeller Estate Pocantico Hills New York March 1983

Hillary Clinton's tea leaves Metropolitan Club Washington DC Feb 11, 1997

 Carol O'Connor's sugar free bridge mix January 29, 1998 New York City

Goldie Hawn's Tennis Cafe Los Angeles November 30, 1996

Stick used in Tea Ceremony for chopping bad tasting Greencake Kyoto 1988

 Ozzy Osbourne's maple syrup bottle Beverly Hills Hotel Coffee Shop May 3, 1998

Walter Cronkite's fortune cookie with fortune by Molly Ivins

 Piece of the gingerbread house The White House Washington DC Christmas 1986

Art Buchwald's toothpick

The President — Place card from Bill Clinton's Birthday Party Waldorf-Astoria Hotel New York City August 18, 1996

BRAIN'S 4 FAGGOTS IN A RICH WEST COUNTRY Sauce — 4 faggots in gravy England 1997

Faye Dunaway's fork New York City 1971

 Howard Stern VOTE

Pearl found in a fried oyster during dinner Le Madeline Cafe New York City 1992

Piece of Jerry Herman's Praline Erie Island

 Brad Pitt's after dinner cigarette Cafe Luxembourg New York City June 14, 1997

Edible Condom

 Crumbs from the wedding cake of Prince of Wales (Edward VII) and Princess Alexandra 1863

 Nancy Reagan's chocolate souffle L'Orangerie Restaurant Los Angeles October 9, 1996

Fish bone that was stuck in the throat of Sverre Wyller Torre Restaurant New York City March 19, 1991

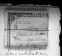 ...for whiskey from National Prohibition Act October 25, 1930

 Wheat infected with Vomitoxin fungal virus North Dakota October 1993

Bill Clinton's husk from steamed corn Clam Bake Martha's Vineyard August 30, 1997

 Piece of plate that was washed as money or package found on the beach of Ouidah, the port of embarkation to "the New World" Benin West Africa

 Bottletop from Leonard Peltier's water Topeka Restaurant Seattle Jan 8, 1994

 Angel food cake picked at by Sharon Stone Chronicon Hotel Phoenix Arizona 1996

Calvin Klein's charge card receipt Cafe Luxembourg January 2, 1998

"Frozen Charlotte doll" about a little girl who froze to death waiting for her brother to arrive with gifts for the Christ child. Story written by Anne Rice

 Christmas cookie baked by Kathryn Hepburn New York City 1995

 Peels from Warren Beatty's pear Carlyle Hotel Dining Room New York City October 8, 1994

Plate used by Al Gore campaign dinner Cooper's Restaurant New York City October 1996

 Giorgio Armani's spoon from cup of espresso Cafe Luxembourg New York City

 Bread balls made by Larry Hagman December 1994

 John Waters' ticket stub and popcorn Film Forum New York City

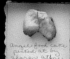 Napkins from Israeli Army Cafeteria

Jerry Seinfeld's cocktail napkin from dinner

Sean Stubbs tooth that fell off while eating Chocolate Tartufo at the Piazza Navona Rome September 1996

Pierre Berge's breakfast napkin Yves St Laurent New York office December 17, 1997

Hotel Jumbo — Gore Vidal's coaster and candle Ravello Italy September 7, 1996

Caroline Kennedy's champagne glass Cafe Luxembourg New York City July 1997

 HRC/NYC — Hillary Clinton birthday cookie 1995

Plastic spoon taken from Harmelodica's White Ford Truck 1994

 SWEET'N LOW — Ivan Goldman's Sweet n' Low and Bustelo strike light Bar Vie New York City April 19, 1998

 Lime from Robert Shapiro's drink The Colonial Restaurant October 27, 1996

Robert De Niro's charge card receipt October 1993

Marinol (THC) appetite stimulant

Concoction to give strength Ivory Coast West Africa 1978

Yoko Ono's charge card receipt from dinner at Cafe des Artistes New York City May 9, 1989

Michael Crichton's candy wrapper and napkin United Airlines flight #20 LA to JFK April 10, 1998

 Terry Gilliam's dessert Jungle Stick from the Jungle Cafe New York City 1994

John Lennon's napkin from restaurant dinner March 22, 1998 New York City

 Lemon peel from Bill Clinton's Inauguration party Washington DC

 Bacon and bean Colonial Cafe New England December

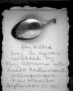 Flea killed by a spoon wielded by Fay Abrams at Scalo Restaurant Albuquerque New Mexico September 23, 1991

 Peyote

POTATO CHIPS 1¢ 1¢

 Steven Spielberg's napkin ring from dinner party 1995

 War ration coupons 1943

 Bottom from Iggy Pop's Apple juice bottle June 25, 1997 Montreal, Canada

 Monogrammed plaster cup of Imelda Marcos New York City 1986

 Do not eat — Bailey Airline 1998

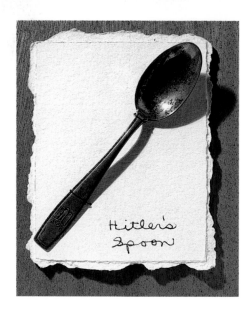

Once someone who was visiting my studio saw the Hitler spoon and asked me if I had ever put it in my mouth!! The answer is NO! ¶

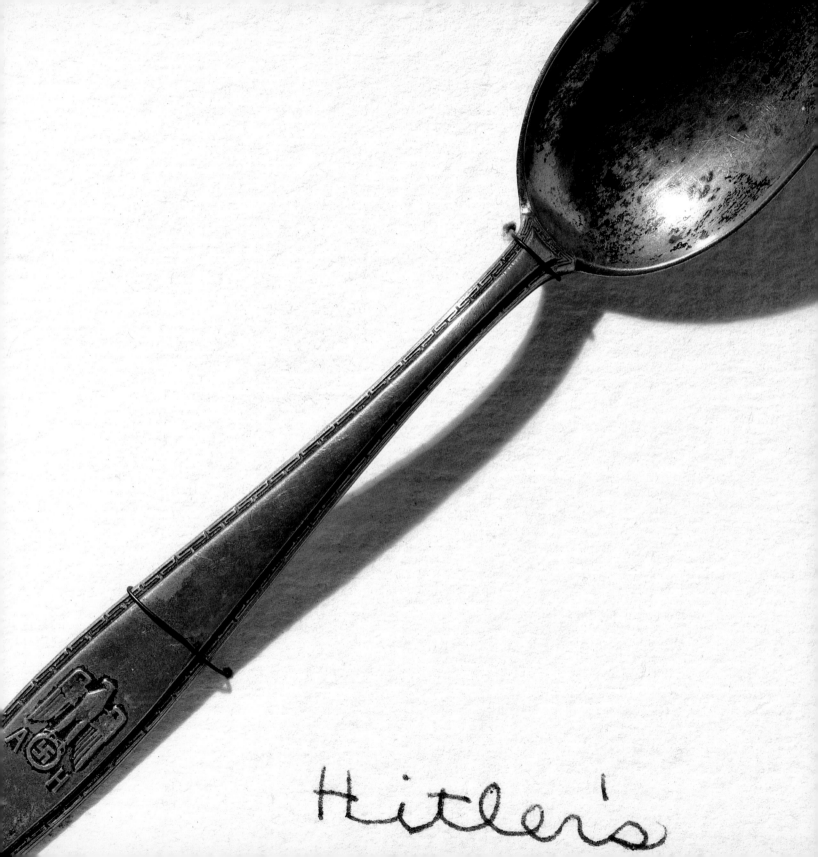

Hitler's

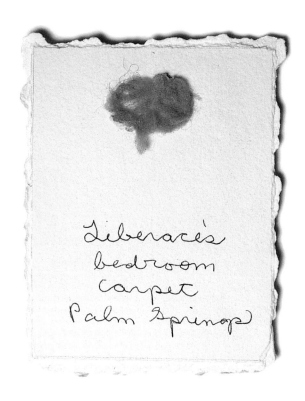

Liberace's
bedroom
carpet
Palm Springs

diskette from
Gene Kelly's
computer

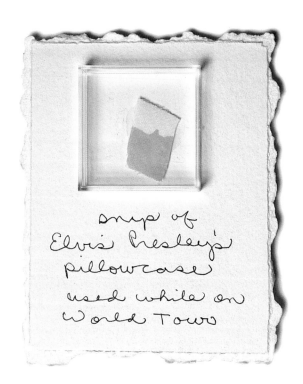

snip of
Elvis Presley's
pillowcase
used while on
World Tour

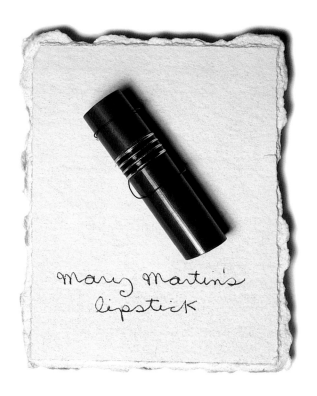

Mary Martin's
lipstick

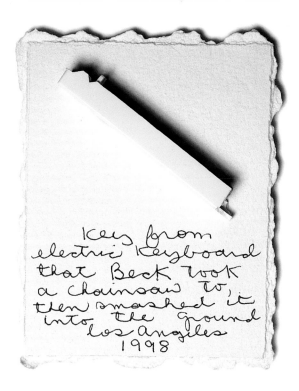

Key from
electric keyboard
that Beck took
a chainsaw to,
then smashed it
into the ground
Los Angeles
1998

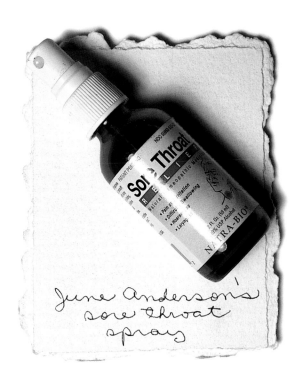

June Anderson's
sore throat
spray

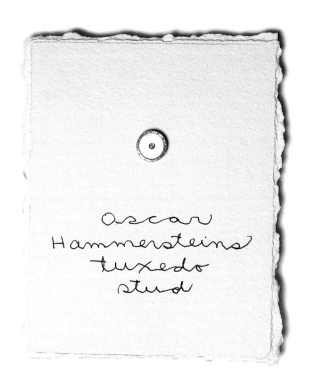

Oscar
Hammersteins
tuxedo
stud

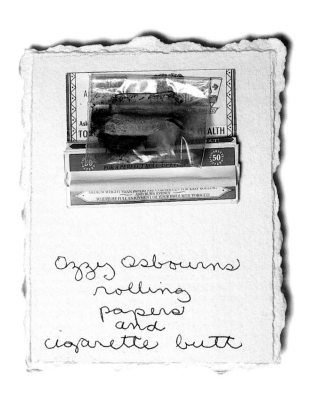

Ozzy Osbourns
rolling
papers
and
cigarette butt

I was talking on the phone to a friend who lives in Santa Monica. He was having a manicure at home while we were talking. He asked his manicurist—an older lady who he knew had taken care of celebrities—if she had anything for me. She said she would send me Frank Sinatra's fingernail. I couldn't believe my luck! ¶ She had also saved a collection of Jack Benny's toenail clippings and sent them as well. I am still waiting to get Ronald Reagan's fingernail clippings from her. ¶

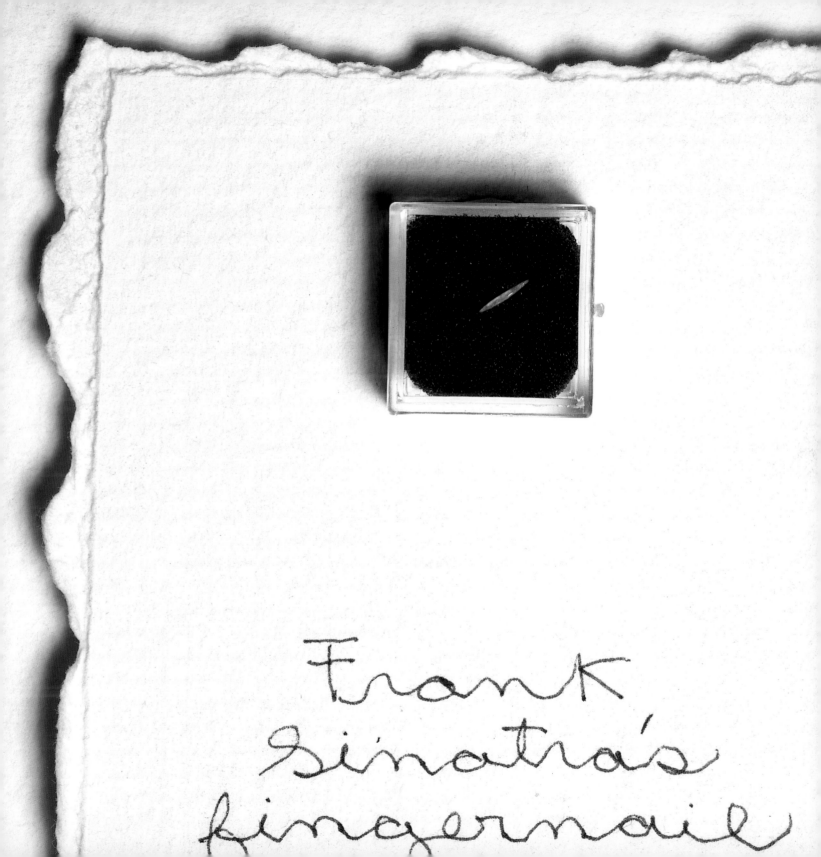

Frank
Sinatra's
fingernail

This museum was inspired by the Swedish Health Authority putting a ban on my exhibition "Lethal Weapons," which was a collection of weapons made with my blood. They were afraid that I would spread AIDS. ¶

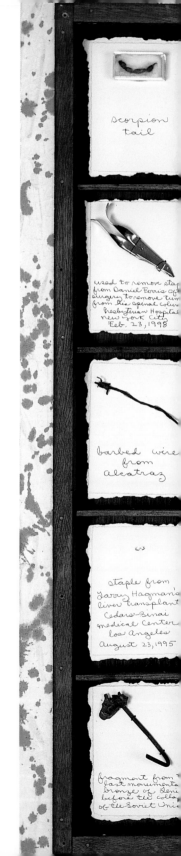

scorpion
tail

used to remove stap
from Daniel Ferris op
surgery to remove tum
from his spinal colum
Presbyterian Hospital
New York City
Feb. 23, 1998

barbed wire
from
Alcatraz

staple from
Larry Hagman's
liver transplant
Cedars-Sinai
medical Center
Los Angeles
August 23, 1995

fragment from
last monumenta
bronze of Leni
before the colla
of the Soviet Uni

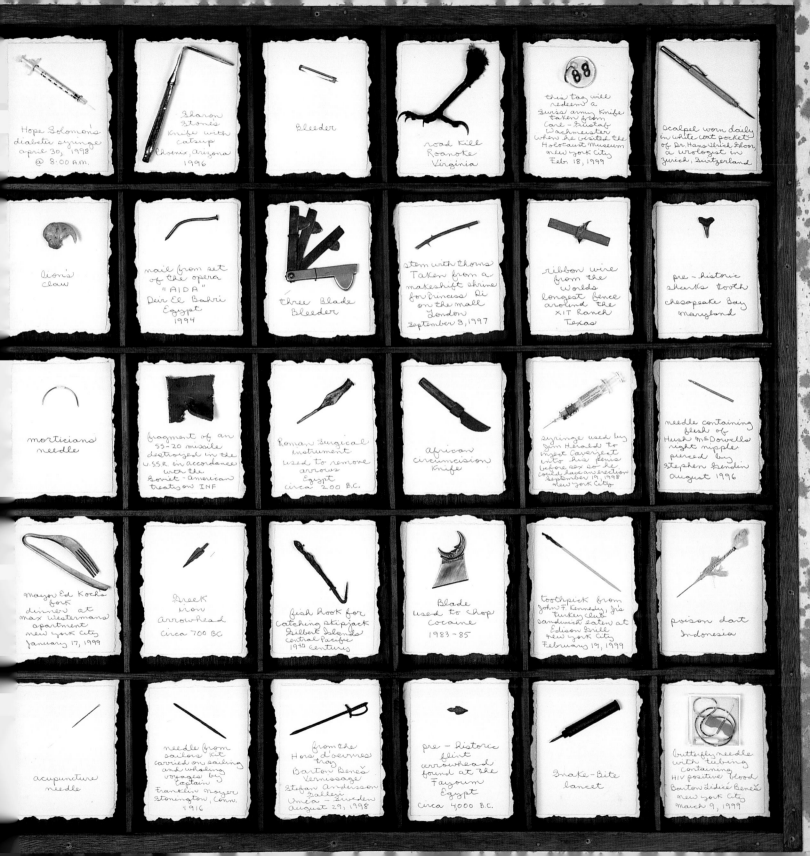

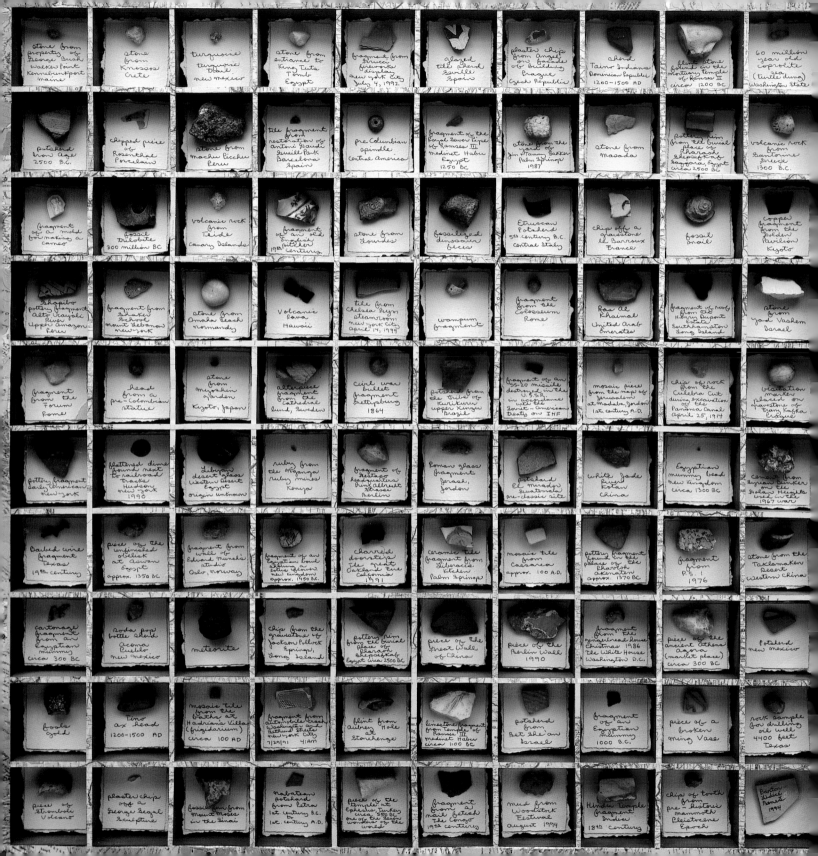

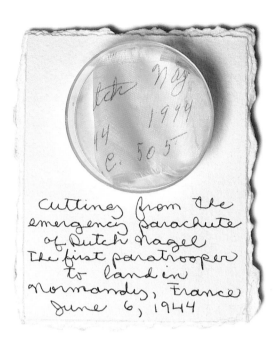

Cutting from the
emergency parachute
of Dutch Nagel
the first paratrooper
to land in
Normandy, France
June 6, 1944

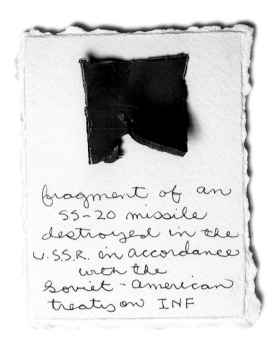

fragment of an
SS-20 missile
destroyed in the
U.S.S.R. in accordance
with the
Soviet - American
treaty on INF

SHARDS MUSEUM: When I was a student I saw a collection of handles that had broken off teacups. It was so inspiring that I decided to make a potpourri of shards from all over the world.

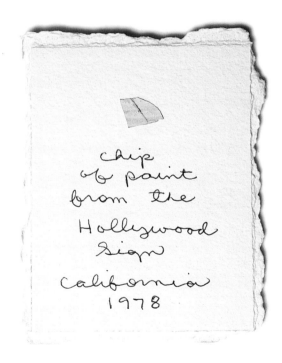

Chip
of paint
from the
Hollywood
Sign
California
1978

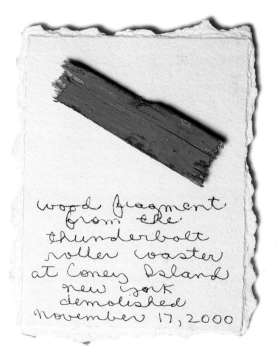

wood fragment
from the
thunderbolt
roller coaster
at Coney Island
new york
demolished
November 17, 2000

A prisoner with AIDS had read a story about me in a magazine and sent me something wonderful. He worked in the prison barbershop and he sent me the hair from David Berkowitz (Son of Sam), collected after a trim. ¶

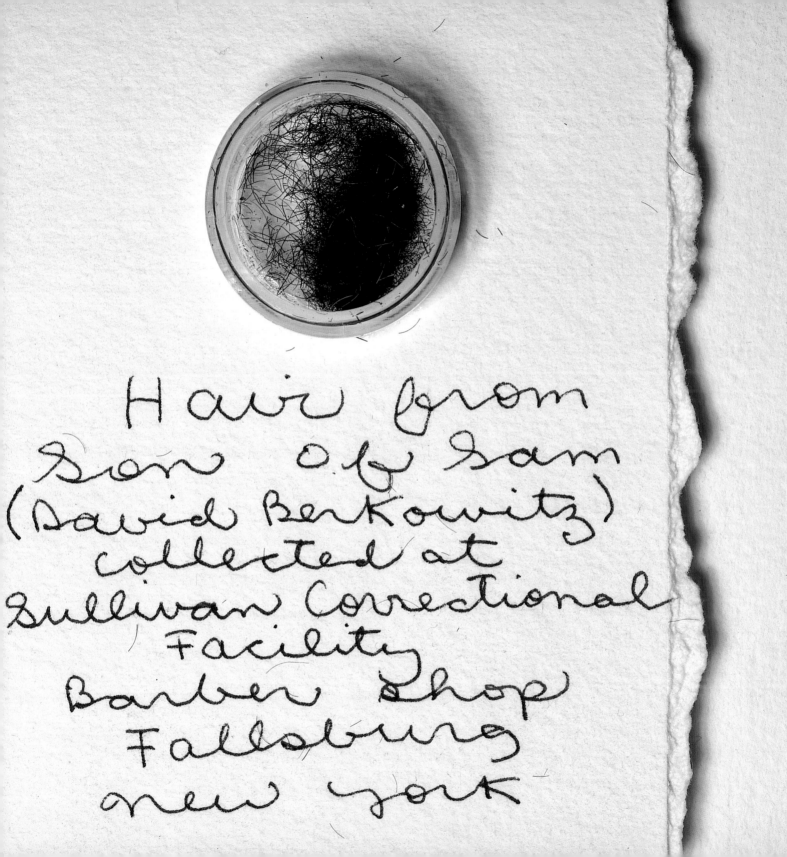

Hair from
Son of Sam
(David Berkowitz)
collected at
Sullivan Correctional
Facility
Barber Shop
Fallsburg
new york

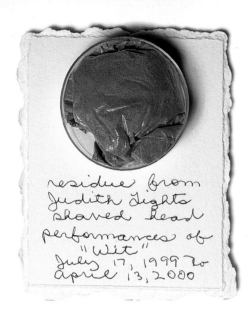

residue from Judith Light's shaved head performances of "Wit" July 17, 1999 to April 13, 2000

A film director arrived in New York from Prague and left an envelope for me that contained the hair of Vaclav Havel with a note from him saying, "Yes, this really is my hair! —Vaclav Havel," with a drawing of a heart. ¶ The hair was supposed to be from his haircut. He knew about my work from my shows in the Czech Republic. This had passed through many hands on the way to me, and when I got it, there was not too much hair, and the note that he had sent me was xeroxed. It seems lots of people along the way had taken some of the hair, and someone had actually taken the original note and thought I could be fooled with the xerox. I have no idea of how many people handled this envelope, but I am happy to have what I have. ¶

HAIR MUSEUM: My aunt once sent me a collection of locks of her hair from when she was a little girl until she was an old lady. There were so many different colors. For my hair collection, I decided to collect every kind, from Vaclav Havel's hair to a headlouse caught by my neighbor's child in school.

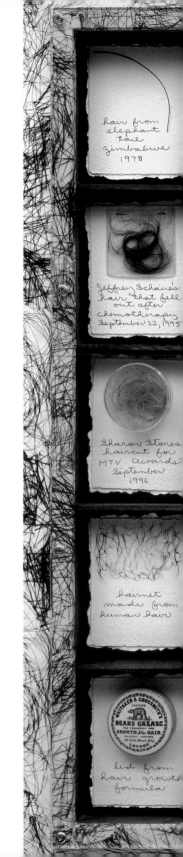

hair from elephant tail zimbabwe 1978

Jeffrey Schaire's hair that fell out after chemotherapy September 22, 1995

Sharon Stone's haircut for MTV Awards September 1996

hairnet made from human hair

lid from hair growth formula

 Václav Havel's hair

Prague
Czech Republic
June 1996

 Christopher Molsted's back hair taken off during Waxing

June 27, 1998

 hair from Harry Byrd's two illegitimate daughters Abigail and Margaret

Winchester, Virginia

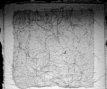 handmade hair paper

 removed from Peter Fonda's hairbrush 1986

 snips of Stephen Gendin's two-colored hair New York City 1997

 photograph by Sally Mann of hair shaved from her Jeep Lexington, Virginia March 1996

 hair from the wife of The Reverend Christian Knudsen November 30, 1820 Sweden

 miniature basket made from horse hair Howard Meyer 1986

 Mary Martin's hair 1990

 Tim Russert's razor New York City June 1994

 Helen Simpson cut her long hair off in May 1921. It was made into puffs by the Killian Bros in Cedar Rapids, Iowa. Cost $3.00

 single lock of hair from native chief measuring 3 feet 11 inches after being braided

New Zealand

head louse from anonymous donor

New York City 1996

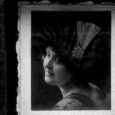 german post card

 hair from Stonewall Jackson 1863

 Hair from Head of Carl Dieker where electrodes were connected while he viewed 48 movies in 78 hours (Guiness Book of World Records)

 hairball from "Angel" American Shorthair Blue Tabby July 1996

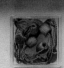 watch chain made from human hair Umea Sweden

 Rastafarian hair

 bracelet made from human hair

 Larry Hagman's Beard Feb. 23, 1992

 Henry Clay Feb. 13, 1850

 makeup and hair on towel that was used to remove makeup from F. Lee Bailey "The Today Show" NBC News March 1995

 snip of hair from a shrunken head

 hair from Mrs. Harrison wife of William Henry Harrison 9th president of U.S.A.

 hair from a Banana fetish Mali

 Burgess Meredith's hair Malibu Beach 1994

 hair from a Camel at The Great Wall China April 6, 1995

 Sean Struba dog Willy's hairs removed from my jacket November 26, 1997

Barton Lidice Beneš

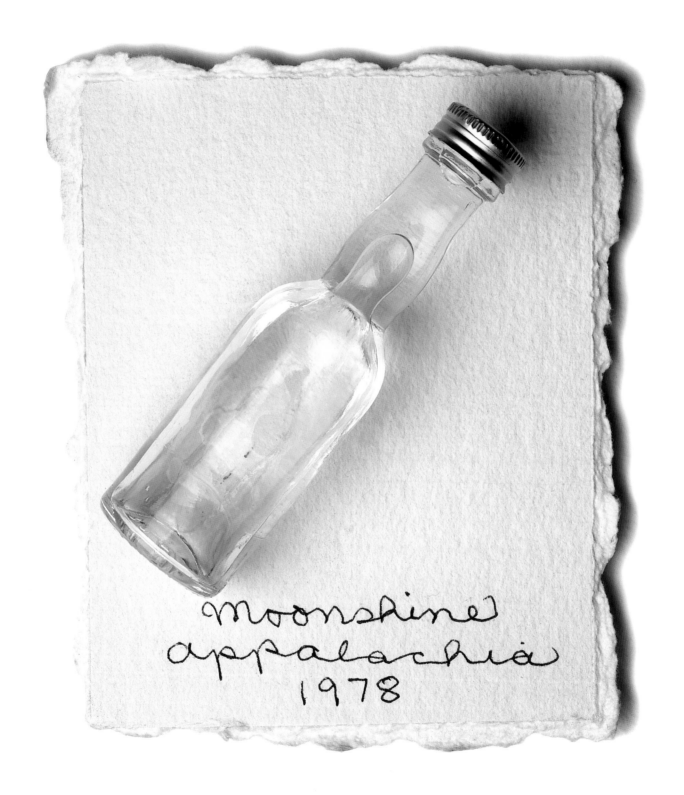

moonshine
appalachia
1978

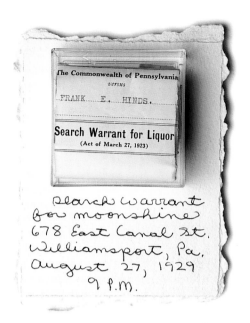

Search Warrant
for moonshine
678 East Canal St.
Williamsport, Pa.
August 27, 1929
9 P.M.

A friend of mine from the South brought me a case of this stuff. I had been trying to remove some arrowheads that were glued to a piece of glass—I tried using paint thinner, lighter fluid, everything, and nothing had worked. Then someone told me to try the moonshine, and, sure enough, it worked. And to think, I used to drink this stuff.❡

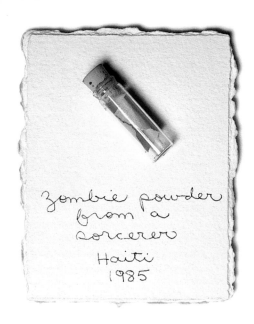

Zombie powder
from a
sorcerer
Haiti
1985

My friend Joe Lovett was producing a segment for 20/20 about zombies in Haiti. He had gone to a voodoo person and had these powders made for the TV show. When he finished with the show he gave me the zombie powder to use for my art. There were little packets made from newsprint with brightly colored powders inside and some writing that I didn't understand. I made some art pieces with them and I put the leftovers into my relic collection. They were like pastels, and I used my fingers to smudge them around. Later, I was told that the powder is absorbed through your skin into your system, and could make you become a zombie. ¶

A voodoo doll that was dug up in a garden near Roanoke, Virginia.

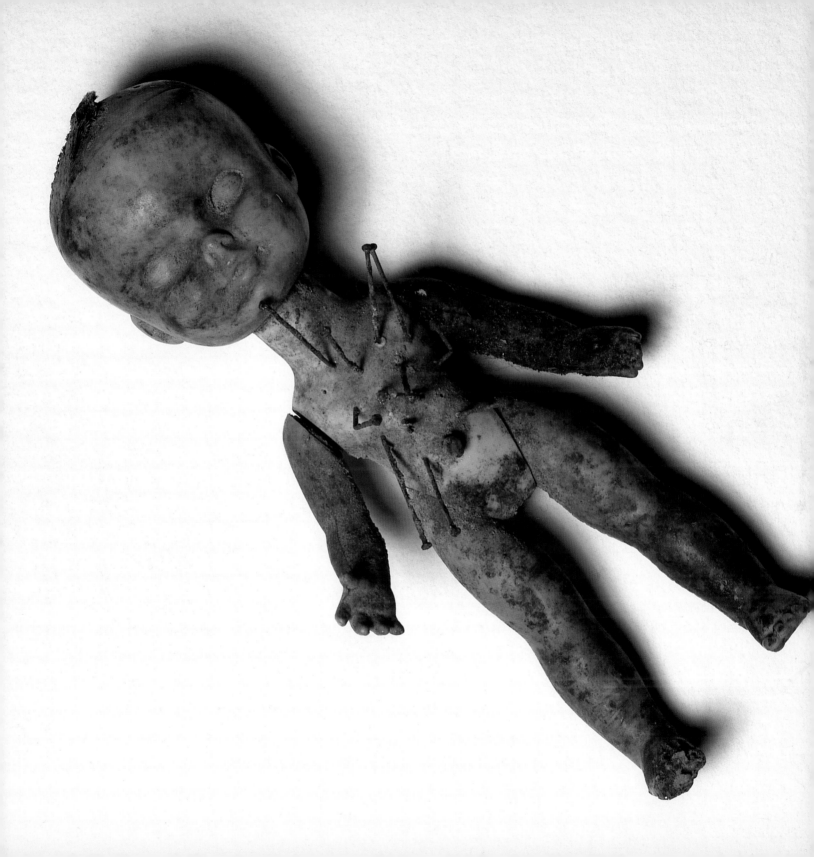

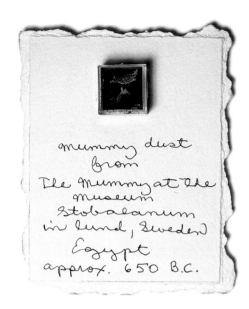

mummy dust
from
The Mummy at the
museum
Stobalanum
in lund, Sweden
Egypt
approx. 650 B.C.

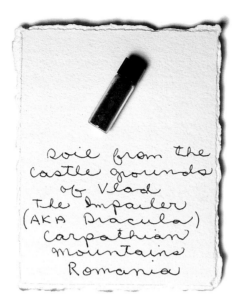

soil from the
castle grounds
of Vlad
The Impailer
(AKA Dracula)
Carpathian
mountains
Romania

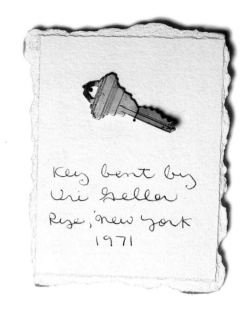

Key bent by
Uri Geller
Rye, New York
1971

Mummy Dust used to be regarded as a powerful aphrodisiac. From what I understand, it would be snorted like snuff. ¶ One day I received in the mail a tin box. I opened it up and found something wrapped in old newspapers. It was a strange creature that looked like a bird, with colorful ribbons around its neck. It had a note attached to it, which said: *"Dried Llama Fetus Fertility Talisman ¶ Bought from a Bruja in hills above La Paz, Bolivia, ¶ During Coup d'etat of July, 1980 ¶ Smuggled in airline passenger's sock past US Customs and Dept. Of Agriculture, Miami Airport, ¶ Shortly thereafter."* ¶ This is an example of how the relics arrive. It is serendipitous. ¶

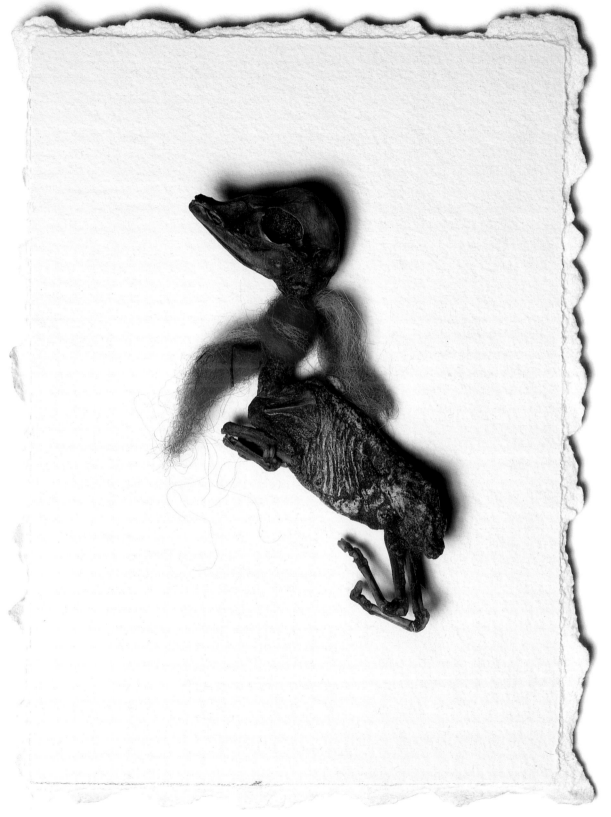

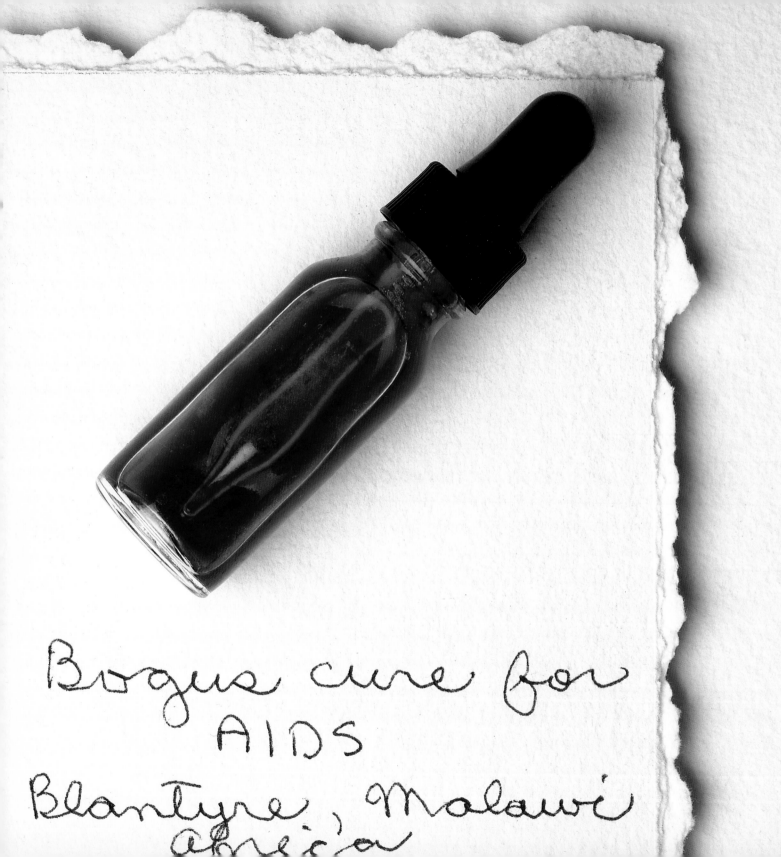

Bogus cure for
AIDS
Blantyre, Malawi
africa

I have an African friend who always brings me fantastic treasures. Lots of serious voodoo stuff, and fetishes of all kinds. He knew that I was collecting AIDS relics, so he visited a healer and brought me a bottle of this potion. It was accompanied by these instructions: TAKE A LITTLE SIP AND SWALLOW IT AND SAY THESE WORDS: ¶ *"I am taking this drug so that you remove all the strange diseases which are in my body, my blood, flesh, and bones, and leave with me only the parts of my body I was born with."* ¶ *After saying the words then finish the remaining drug in the cup. Then wait for one hour. Now during the one hour period you may either vomit or be weak. Do not worry, these are the signs. So after one hour take the same measurement and pour it in a basin and stir it. Then go to the bathroom and wash the legs and then arms and lastly wash the head. That is on the first day. You skip a day and then on the second day just grab the whole bottle and say the same words and put it in the cup of the same measurements. After 40 minutes drink the whole at once.* ¶

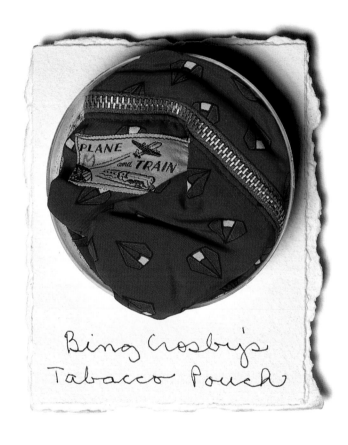

Bing Crosby's
Tabacco Pouch

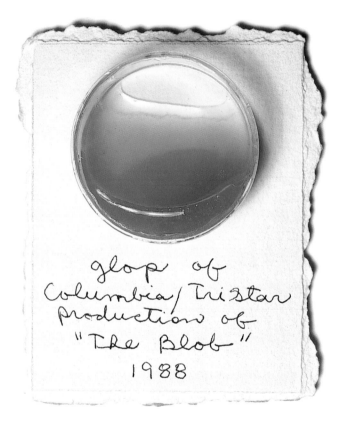

glop of
Columbia/TriStar
production of
"The Blob"
1988

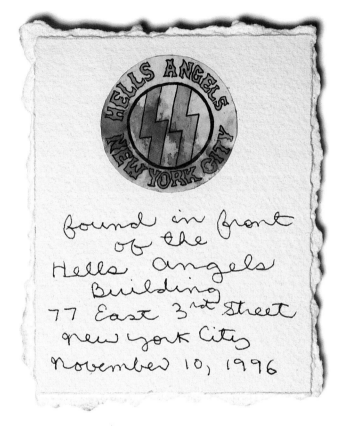

found in front
of the front
Hells Angels
Building
77 East 3rd Street
New York City
November 10, 1996

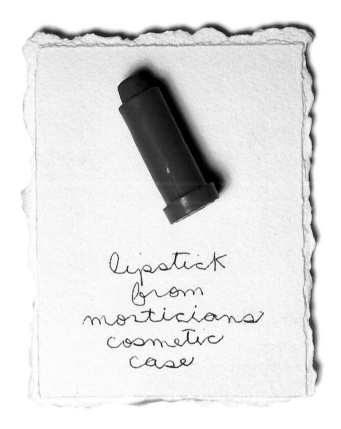

lipstick
from
morticians
cosmetic
case

leaf from Burning Bush St Catherines Monastery Sinai

fragment from the reliquary that contains the skull of Saint Corbinian the missionary Saint of Bavaria Cathedral of Freising

Holy Water from the River Jordan

rosette from the chapel of the Hospital de los Venerables Seville

Saint Teresia of the Infant Jesus

Calvary

garden of Gethsemane

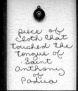

piece of cloth that touched the tongue of Saint Anthony of Padua

Lefevre Priests performed an exorcism on this medal Munich 1980

Pope Pius X

relic of Saint Laboure

Marble from the Mary Magdalena altar made by Bernini in the Church of Saint Dominic and Saint Sixtus Rome

particle from the body of Saint Elizabeth Ann Seton

piece of Mother Cabrini's habit

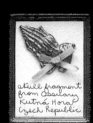

skull fragment from Ossuary Kutná Hora Czech Republic

Abrahams Oak Hebron

Bishop of Philadelphia Saint John Neuman

relic from the shrine of Fatima Portugal

wax from Easter candle burnt at Saint Peters in Rome and blessed by the Pope

relic of Saint Joseph

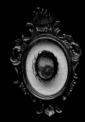

bone fragment from Saint Theresa of the little flower

mount of Olives

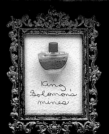

King Solomon's mines

Holy dirt from Sanctuario Chimayo New Mexico

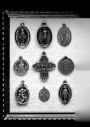

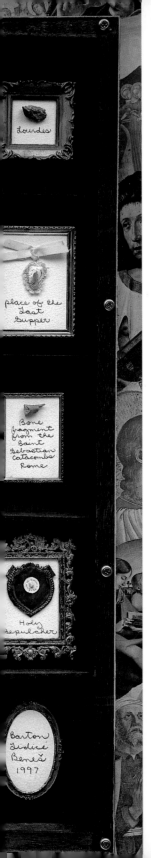

When you purchase a relic of a saint, the dealers don't charge for the relic, just the case that the relic is in. Trading in religious relics used to be a big business. You can get lots of relics out of one piece of cloth. ❡

RELIQUARY MUSEUM.

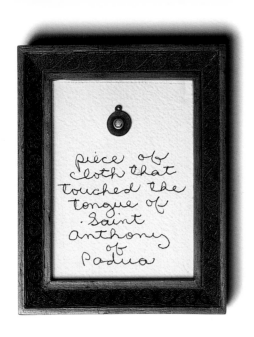

I inherited a collection of religious relics but didn't know how to identify them. I decided to put all the relics together into one collection and then I called a girl who I used to baby-sit. Since then, she'd restored reliquaries in Germany and had received her doctorate in art history. She was able to identify the relics and label most of them for me. ❡ My favorite one is a piece of cloth that touched the tongue of Saint Anthony of Padua. I asked her how they did this. She said there is a reliquary with his tongue and this piece of cloth was pressed against that tongue. When I asked why, she said he gave good sermons.❡

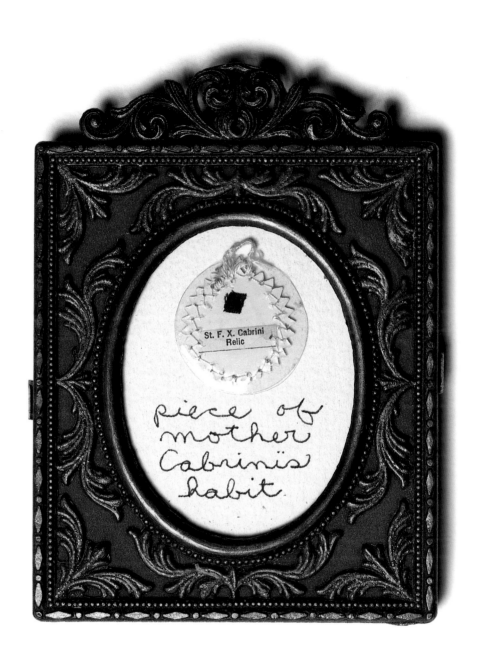

St. F. X. Cabrini
Relic

piece of
mother
Cabrini's
habit

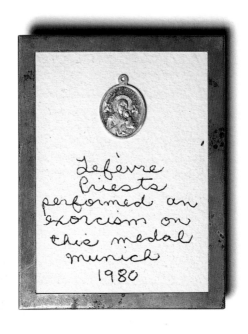

Lefèvre
Priests
performed an
exorcism on
this medal
munich
1980

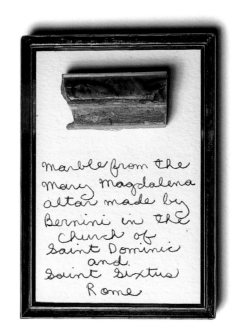

Marble from the
Mary Magdalena
altar made by
Bernini in the
church of
Saint Dominic
and.
Saint Sixtus
Rome

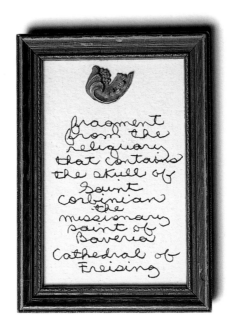

fragment
from the
reliquary
that contains
the skull of
Saint
Corbinian
the
missionary
saint of
Bavaria
Cathedral of
Freising

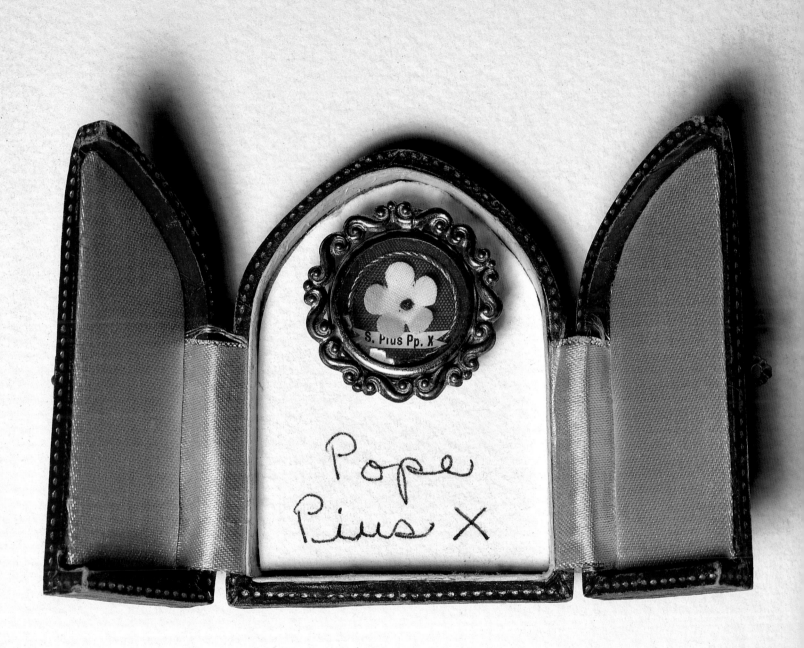

Jelly Beans
from the
desk of
Ronald Reagan
Washington D.C.
1985

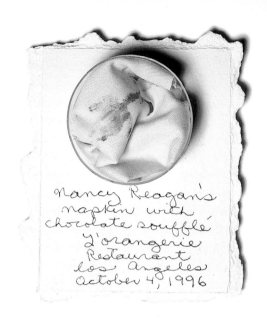

Nancy Reagan's
napkin with
chocolate soufflé
L'orangerie
Restaurant
Los Angeles
October 4, 1996

Two friends of mine were having dinner at l'Orangerie in Los Angeles and were seated next to Nancy Reagan. They decided they would swipe something for me from her table. To get the documentation, my friend made believe he was taking his friend's picture, when in fact he was taking a picture of Nancy wiping the chocolate soufflé from her lips. The napkin was the target. When she left, they quickly picked up the napkin from the table and pocketed it for me. A letter arrived with the napkin saying, "Nancy's the culprit and the napkin is the victim!" ¶

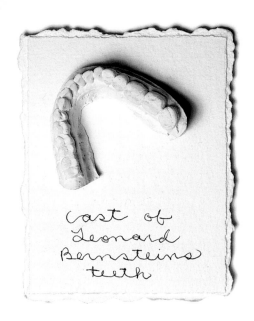

cast of
Leonard
Bernsteins
teeth

I was at a dinner party with John Berendt, and we were sitting next to someone who was a very close friend of Leonard Bernstein. John said to him in an intimidating voice, "What are you going to give Barton for his museums?" He said, "I have a cast of Leonard Bernstein's teeth." So, thanks to John playing the heavy, I arranged to get them. ¶ Then, one day he called and asked to have them back, saying he had merely lent them to me. I was furious. There was no way I could part with those. So at my next dental appointment, I brought the teeth with me, and the dentist's assistant cast them for me as a favor. ¶

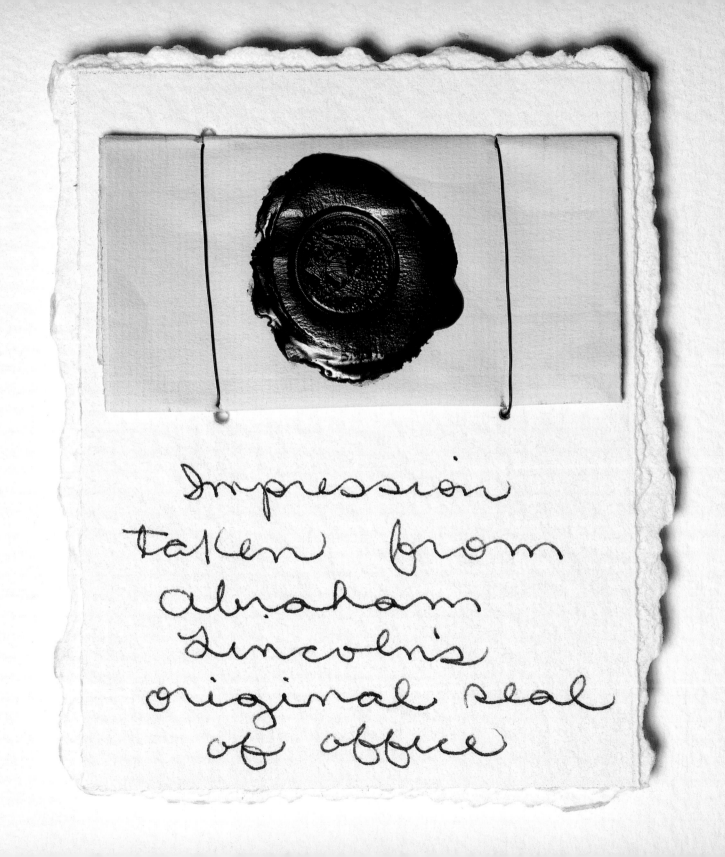

Impression
taken from
abraham
Lincoln's
original seal
of office

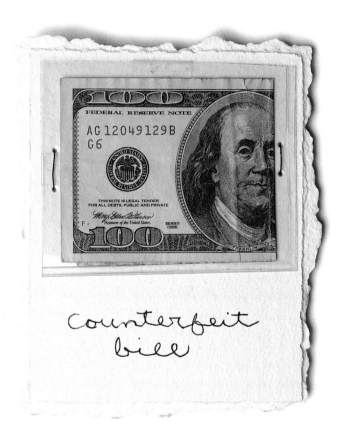

counterfeit
bill

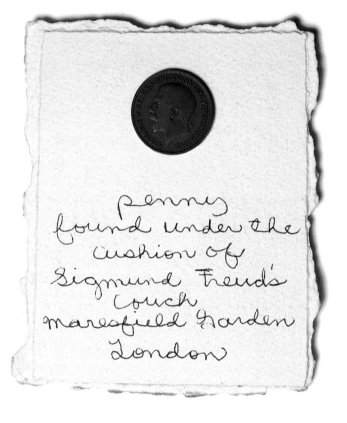

penny
found under the
cushion of
Sigmund Freud's
couch
Maresfield Garden
London

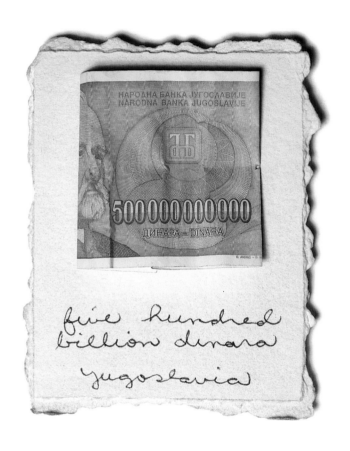

five hundred
billion dinara
yugoslavia

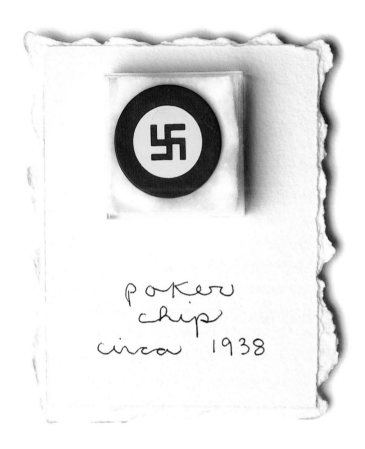

poker
chip
circa 1938

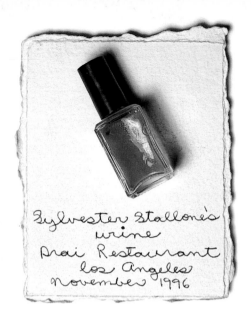

Sylvester Stallone's
urine
Drai Restaurant
Los Angeles
November 1996

One of my art dealers was in the men's room in a Los Angeles restaurant and was at the urinal next to Sylvester Stallone. Stallone didn't flush, so my dealer emptied a pill bottle and scooped out some urine for me. I could never do anything like that—I leave the dirty work for others to do. ¶ Then I got nervous wondering if I could get in trouble, but everyone told me "He didn't flush, so he can't complain" In this age of DNA, the urine can always be verified for proof. ¶

CELEBRITY MUSEUM (detail).

lens from Mary Crosby's sunglasses Malibu

water from Dick Van Dyke's swimming pool

Kathleen Turner's cigarette butt Cafe Des Artistes New York City 1987

monogramed plastic cup from the bathroom of Imelda Marcos New York City 1986

stone from Angela Lansbury's home County Cork Ireland

Valentine from Henry Fonda to Susan Blanchard 1950

snip of Chris O'Donnell's Christmas tree Los Angeles California 1998

Johnnie Cochran's handkerchief worn Feb. 1, 1995 in O.J. Simpson case while Ron Shipp was on stand — make-up stain from interview with Katie Couric NBC-TV

piece of Lucille Ball's home at 1000 N. Roxbury Drive Beverly Hills California

Jacqueline Kennedy's signature

Mary Martin's hair

Leonard Bernstein's secret for "Book of Secrets" New York City 1978 — "Some part of me deeply believes I am a fraud." Leonard Bernstein

heel from James Cagney's shoe

pearl from bracelet worn by Minnie Driver in "Big Night" Keansburg New Jersey 1995

Debbie Reynold's lip liner St. Moritz Hotel New York City January 13, 1995

Eddie Rabbit's guitar string Las Vegas November 1985

Roy Rogers Snot in Nasal Douche Desert Knolls Pharmacy Apple Valley California Feb. 13, 1969

Birdseed from David Geffen's parrot Malibu 1994

Oxygen tube used by Ace Frehley of "Kiss"

Fragment from Shirley Temple's doll house Los Angeles 1990

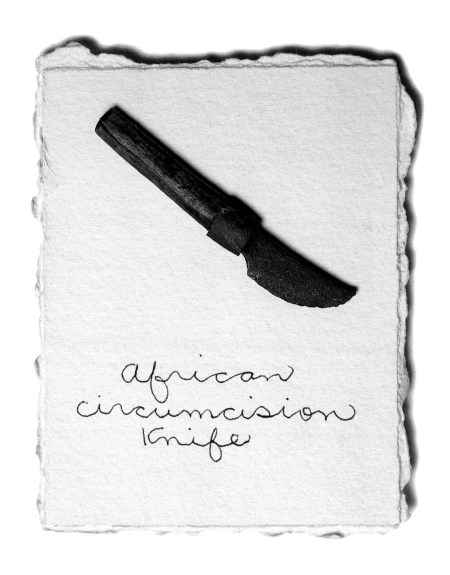

African
circumcision
Knife

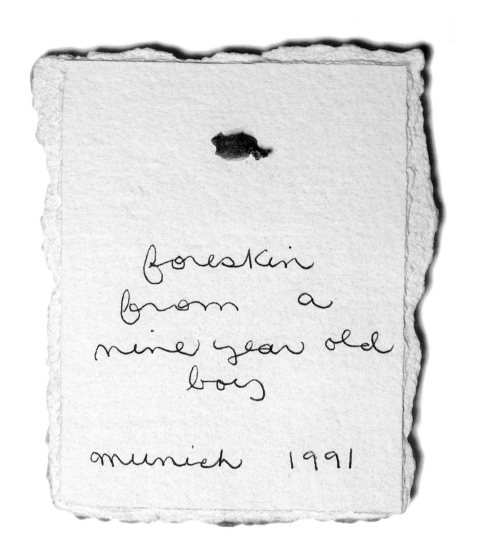

foreskin
from a
nine year old
boy

munich 1991

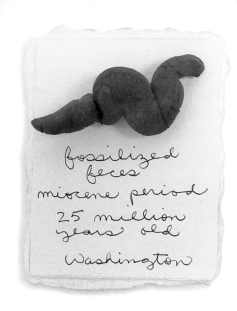

*fossilized
feces
miocene period
25 million
years old

Washington*

Stephen Jay Gould came over with friends several years ago to visit my studio. I didn't know who he was. I showed him my collections and pointed out some dinosaur feces. He looked at it carefully and said that it wasn't dinosaur feces. And I said in a petulant voice, "How would you know?" ¶ My friends told me that he was a famous paleontologist. I was totally embarrassed. But now, thankfully, I have real fossilized feces, clocking in at 25 million years old. ¶

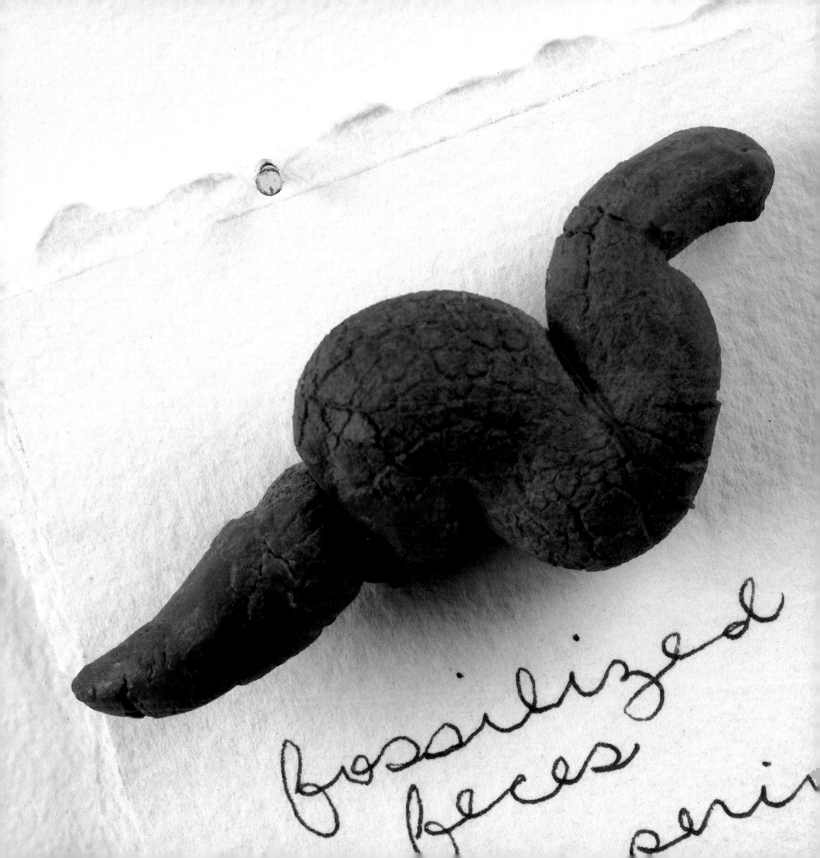

fossilized
feces
spri

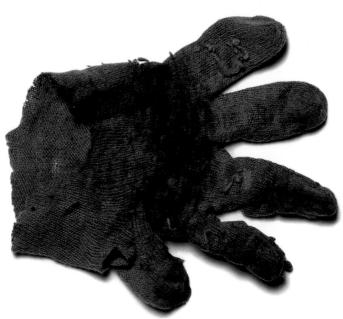

I was obsessed with the O.J. Simpson murder trial. I'd even made a reliquary about the trial. So when I met Alan Dershowitz at a dinner party, I asked him if he could send me something. He did. See the letter (*opposite*). ¶ In the tradition of reliquaries, I try to get as much from a relic as possible, so I had removed the lining from the glove. Then, in 2000, someone stole the glove from my studio, along with the original letter. Luckily, I still had the lining and a copy of the letter. But let it be known that the O.J. glove is missing again! ¶

HARVARD LAW SCHOOL

1575 MASSACHUSETTS AVENUE
CAMBRIDGE • MASSACHUSETTS • 02138

ALAN M. DERSHOWITZ
Felix Frankfurter Professor of Law

520 HAUSER HALL
(617) 495-4617

March 23, 1999

Mr. Barton Lidice Benes
Westbeth
55 Bethune Street
Apt # 956H
New York, NY 10014

Dear Mr. Benes:

I am enclosing the glove that I used to conduct the experiments on, regarding the possible planting of evidence by Mark Fuhrman. When the glove was dampened and left outside in conditions simulating those in Los Angeles on the night of the murder, it dried quickly. But when the same dampened glove was sealed in a baggie, it remained moist. Fuhrman claimed it was moist when he found it hours after the killing.

Sincerely,

Alan Dershowitz

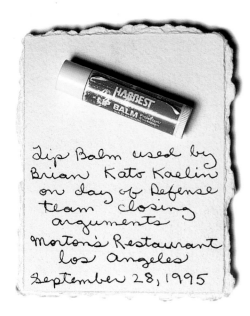

Lip Balm used by Brian Kato Kaelin on day of Defense team closing arguments Morton's Restaurant Los Angeles September 28, 1995

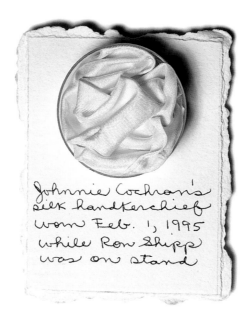

Johnnie Cochran's silk handkerchief worn Feb. 1, 1995 while Ron Shipp was on stand

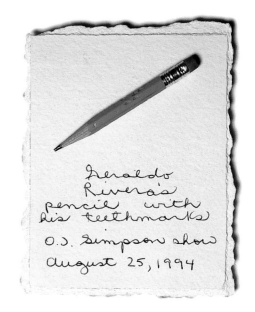

Geraldo Rivera's pencil with his teethmarks O.J. Simpson show August 25, 1994

I know a producer of a national news program, and she interviews people before they appear on the show. She was having lunch with Brian "Kato" Kaelin the day the defense team was closing arguments on the O.J. Simpson trial. I knew that she was going to see him and begged her to get me a relic. She was very aggressive and asked him for something. He said he didn't have anything, so she said, quite forcefully, "Give me your wallet!" She went through it and found a parking ticket. She asked for it, but he refused, saying he needed to pay it. Then, as he was putting on lip balm, she swiped it from him. When he said, "Hey, give that back," she wouldn't. And now I have his wild cherry Chapstick. ¶

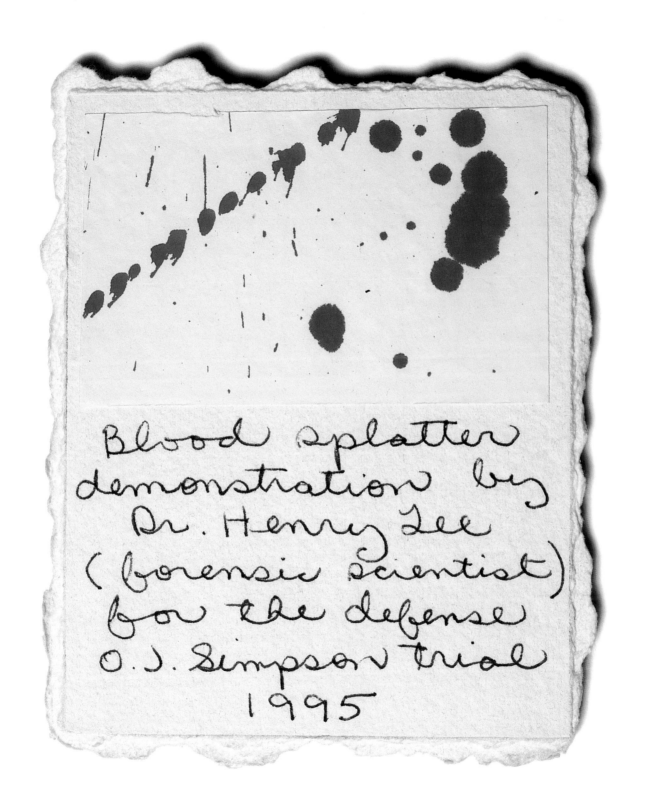

Blood splatter
demonstration by
Dr. Henry Lee
(forensic scientist)
for the defense
O. J. Simpson trial
1995

TRANSUBSTANTIATIONS: *I felt the need to take the relics to another place—I wanted to turn the relic into the subject it was about.*

Friends of mine were driving by O.J. Simpson's house on Rockingham Drive as it was being torn down. They went in and picked up a piece of wood for me, and the police came and asked them what they were doing. My friends pleaded with them, saying they had a friend who was an artist and needed the wood to make something. The police said, "If you really need it that badly, go ahead and take it." So this piece of wood was sent to me. It looks like it could have held up the air conditioner in Kato Kaelin's room! I cut the block of wood into small pieces and fitted them together to create a knife.

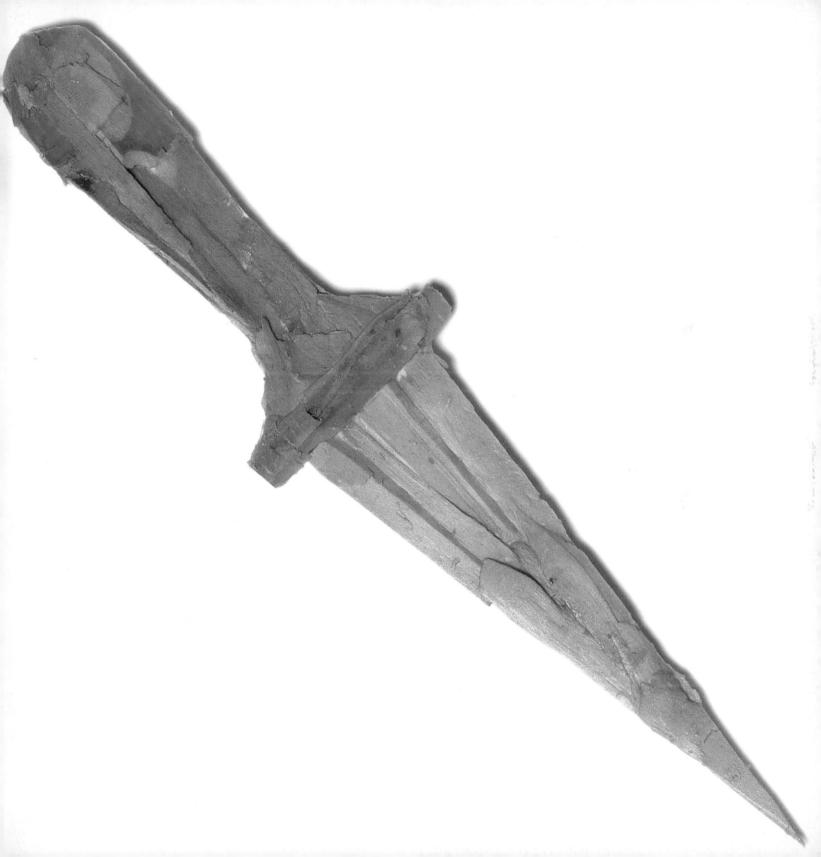

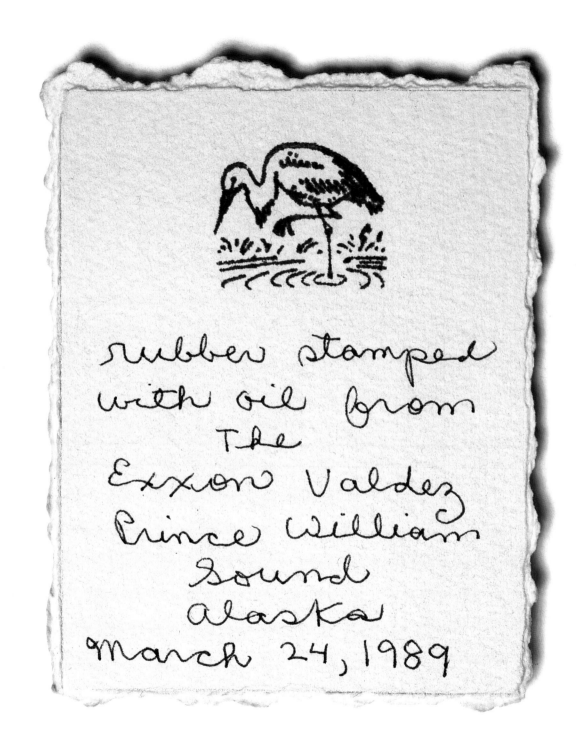

rubber stamped
with oil from
The
Exxon Valdez
Prince William
Sound
Alaska
March 24, 1989

A friend, and the person who makes my frames, worked as a chef for Exxon. He brought me oil from the *Exxon Valdez* oil spill in Prince William Sound in Alaska. I needed a metaphor for the oil and I found an old rubber stamp of a crane standing in the water. I put the oil from the *Valdez* into a stamp pad and stamped the bird out with the oil. It was the perfect symbol for all the wildlife that was destroyed because of this catastrophe. ¶

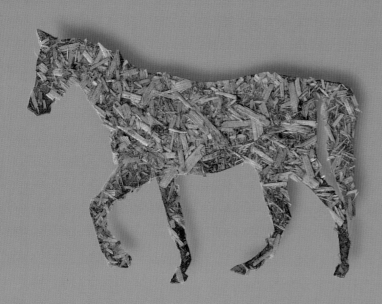

Larry Hagman's secretary was driving in a car behind Lindsay Wagner's horse. The horse dropped a load on the road, and after her tires went over it she thought of me. She picked up a piece of flattened horse manure and sent it to me Federal Express. I was shocked when I opened the envelope and found shit inside, until I found out the story! I let it dry out a lot more and then cut the shape of a horse out of it with an exacto blade. ¶ A friend got into Tammy Bakker's yard and took some of her palm branches for me. He was thinking religion and Palm Sunday, but I was thinking eyelashes! ¶

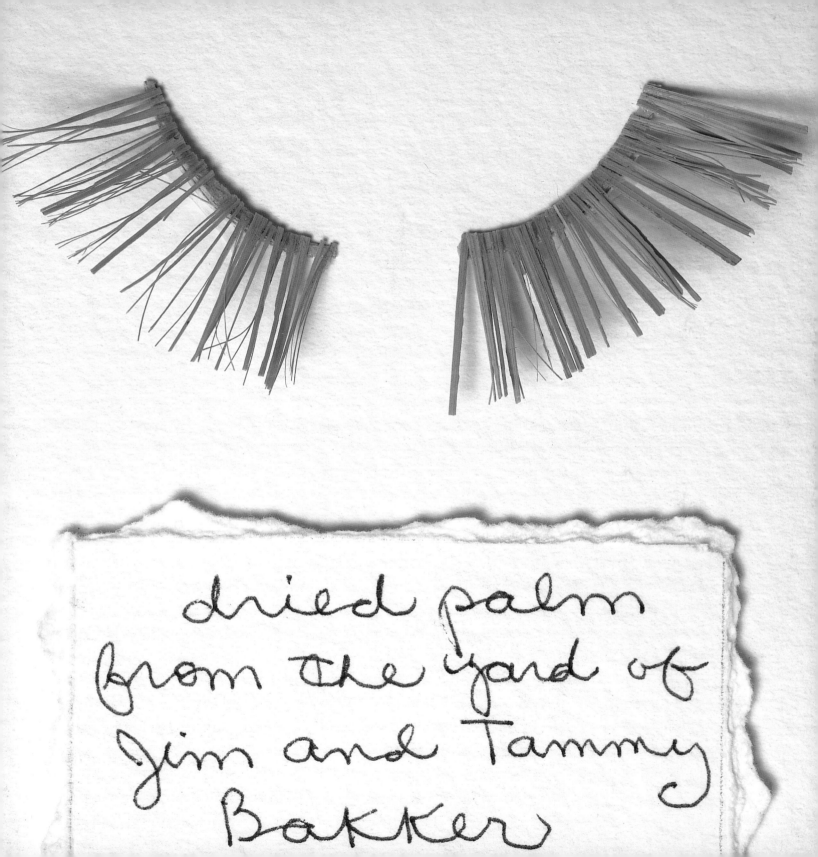

dried palm
from the yard of
Jim and Tammy
Bakker

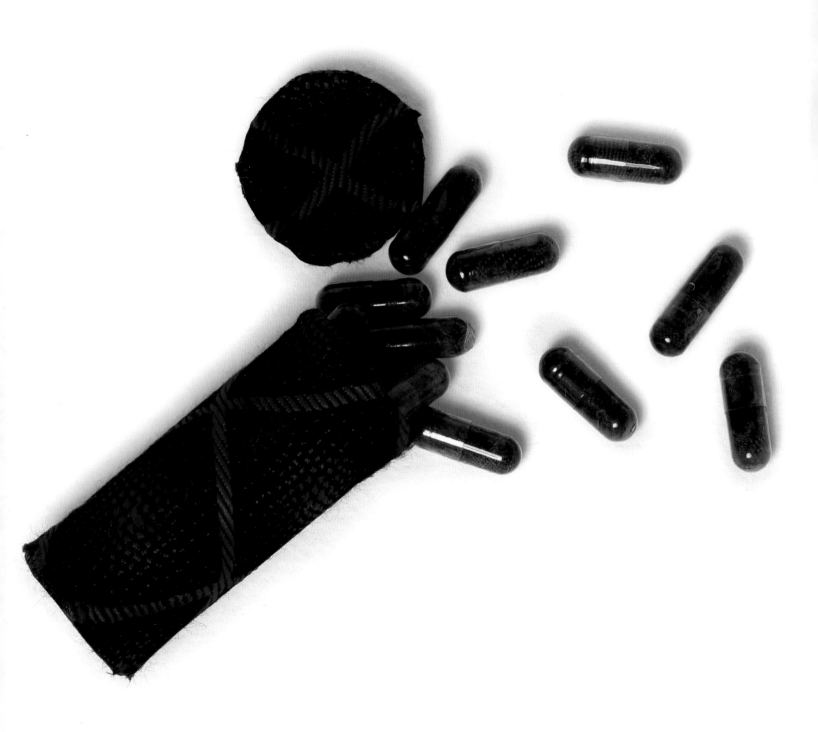

My friend, artist Frank Moore, told me he had something that I would die for. He had Mark Rothko's prescription for anti-depressant pills. The prescription had never been filled. I was so anxious to get this, but then he couldn't find it. So he gave me some neckties that had belonged to Rothko—ties that he would wear to his openings. One of the ties even had paint spattered on it. Since I didn't have the prescription, I decided to make his tie into a bottle of pills. I covered a pill bottle with the tie, and then I took the threads and filled gelatin capsules with the threads from the tie, and I have the pills spilling out of the bottle. ¶

POSTSCRIPT

I made an exhibition of objects that contained my HIV-positive blood. It all started one day when I was cutting parsley in the kitchen and cut my finger. There was blood everywhere. I panicked and started to clean everything with bleach, when I realized how crazy this was. I was afraid of my own blood. That was when I became aware of what a powerful metaphor this was and decided to make a series called "lethal weapons." If I was afraid of my own blood, one could imagine how an ignorant public would feel. I filled water pistols with my blood, made Molotov cocktails, poison darts, joke squirt flowers, etc. ¶ The Anders Tornberg Gallery in Lund, Sweden, decided to show these pieces. I went over for the opening, and the newspapers did lots of stories. When I returned to the States a few days later I received a telephone call from my gallery saying, "We have big trouble." It seemed as though the Swedish Health Authority had put a ban on my work. The press went wild, not just in Sweden but also all over the world. The case went to the Swedish court, and I had to hire a lawyer to represent me. I had a doctor from Sloan-Kettering write a letter to the court asking them what the problem was, were they planning on eating the art?! The situation was turning into a circus, but finally the Swedish Court offered a compromise. They said that my work could be taken to a hospital and heated up to 160 degrees to kill off anything that might be in the blood. I agreed, the work was heated, received the proper certificates, and the gallery was able to show the works and sell them. We wound up selling lots of my blood! Then I had to pay the lawyer—I couldn't even imagine what this would cost. She offered to do barter, so I gave her an ounce of my blood, in a holy water bottle, for services rendered. ¶

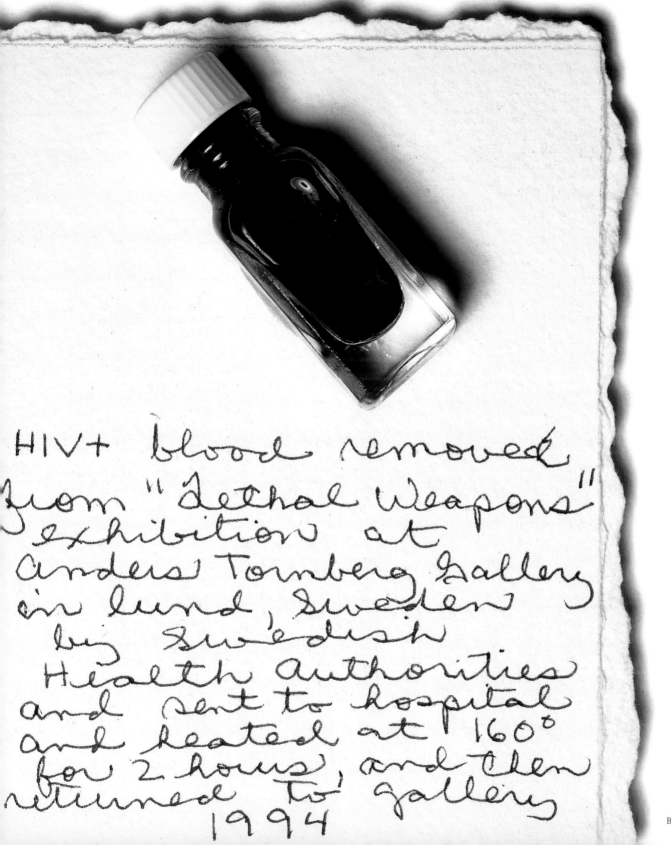

HIV+ blood removed
from "Lethal Weapons"
exhibition at
Anders Tornberg Gallery
in Lund, Sweden
by Swedish
Health Authorities
and sent to hospital
and heated at 160°
for 2 hours, and then
returned to gallery
1994

This book is dedicated to Jeffrey Schaire. He was the one who told me I should meet Martha Kaplan, who is now my literary agent. I never called her, and he got very angry with me for never following up on his advice. ¶ When he died, I went to his funeral, and everybody had to shovel some dirt on top of the coffin. I was waiting behind a woman to shovel my dirt in, and we were both crying and hugged each other. She introduced herself to me saying, "I'm Martha Kaplan." I told her fate would have it that we should meet this way. Jeffrey finally did get us together.¶

CREDITS

PAGE 2: DEATH MUSEUM, 54 1/2" X 53 1/2" X 2 3/4", 1995, PRIVATE COLLECTION OF MR. RICHARD W. VAGUE.

PAGE 6: OSSUARY, SILKSCREEN PRINT, 33 1/2" X 29 1/2", 2001, COURTESY OF THE HAND PRINT WORKSHOP.

PAGE 10: CELEBRITY MUSEUM, 50 1/2" X 60" X 2 3/4", 1994, FROM THE PRIVATE COLLECTION OF MR. RICHARD W. VAGUE.

PAGES 24-25: ARTISTS MUSEUM, 1992-1999, FROM THE PRIVATE COLLECTION OF MATTHEW AND ANN WEIR.

PAGE 71: FOOD MUSEUM, 57" X 54 1/2" X 2 3/4", 1998, COURTESY LENNON WEINBERG GALLERY, PHOTOGRAPH BY NICK.

PAGE 78: SHARP MUSEUM, 35" X 40 1/2" X 2 3/4", 1999, COURTESY LENNON WEINBERG GALLERY, PHOTOGRAPH BY DAVID CORIO.

PAGE 80: SHARDS MUSEUM, 39 1/4" X 39 1/4" X 3 1/2", 1994, COURTESY LENNON WEINBERG GALLERY, PHOTOGRAPH BY NICK.

PAGE 84: HAIR MUSEUM, 35" X 40 1/2" X 2 3/4", 1998, FROM THE PRIVATE COLLECTION OF BARRY AND BARBARA COLLER.

PAGE 96: RELIQUARY MUSEUM, 35" X 40 1/2" X 2 3/4", 1997, COURTESY LENNON WEINBERG GALLERY, PHOTOGRAPH BY NICK.

ALL OTHER PHOTOGRAPHS IN THE BOOK ARE BY DAVID CORIO, EXCEPT THOSE ON PAGES 30, 72, AND 102, WHICH ARE BY GEOFFREY SPEAR.

ACKNOWLEDGMENTS

I would like to thank the countless friends who have provided me with relics for my collections. I could never have done this without the enthusiasm from all the people who have sent me relics. Thanks to Ellen Nidy, Michael Walsh and Maggie Chace at Abrams, who were wonderful to work with. Special thanks to all those who were exceptionally generous with their help on this book. And thanks to Stephanie Becker, John Berendt, Bob and Pat Brier, David Corio, Alan Dershowitz, Michael Epstein and Scott Schwimer, Paul Epstein, Larry and Maj Hagman, Andy Hughs, Martha Kaplan, Tom McNemar, Howard Meyer (deceased), Kevin O'Leary, Bill and Nancy Rollnick, Stephanie Walker, and the American Museum of Natural History, where I spent all my Sundays as a child. I would also like to thank the unknown monk at the catacombs in Rome, from whom I stole a bone, which started this obsession.

I would like to thank the following people and their galleries, museums, and magazines:
Nelson Santos, VISUAL AIDS (NYC); Jill Weinberg and Tom Adams, LENNON WEINBERG GALLERY (NYC); Stefan Andersson, GALLERI STEFAN ANDERSSON (Umea, Sweden); Laurel Reuter, NORTH DAKOTA MUSEUM OF ART (Grand Forks, ND); Marge Devon, TAMARIND INSTITUTE (Albuquerque, NM); Dennis O'Neil, HAND PRINT WORKSHOP (Alexandria, VA); Manuel and Arlette De Britto, GALERIA 111 (Lisbon, Portugal); Datel Novotny, "TOGETHER AGAINST AIDS" (Prague, Czech Republic); Sarah Tanguy, CURATOR FOR "A VIEW FROM HERE," TRETYAKOV GALLERY (Moscow); Barbara Coller, MILLENNIUM MESSAGES (Smithsonian Institution Traveling Exhibition); Richard Klein, ALDRICH MUSEUM (Ridgefield, CT); Anders Tornberg, ANDERS TORNBERG GALLERY (Lund, Sweden); UPPSALA KUNSTMUSEUM (Uppsala, Sweden); MUSEOKESKUS VAPRIIKKI (Tampere, Finland); Sean Strub, POZ MAGAZINE (NYC); Jeffrey Schaire (deceased), ART & ANTIQUES MAGAZINE (NYC).

EDITOR: Ellen Nidy

ART DIRECTOR/DESIGNER: Michael J. Walsh Jr.

PRODUCTION COORDINATOR: Maria Pia Gramaglia

LIBRARY OF CONGRESS CONTROL NUMBER: 2002105526

ISBN 0-8109-3537-6

PRINTED AND BOUND IN HONG KONG

10 9 8 7 6 5 4 3 2 1

HARRY N. ABRAMS, INC.
100 FIFTH AVENUE
NEW YORK, N.Y. 10011
WWW.ABRAMSBOOKS.COM

ABRAMS IS A SUBSIDIARY OF